IMAGES
of America

LEWISTON

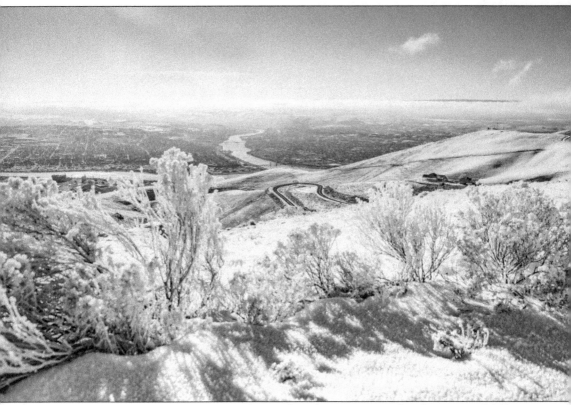

If one has ever lived in the Lewis-Clark Valley, the Lewiston Hill will remain indelible in one's memory. Once visitors see the height of the Lewiston Hill, they will never forget it, while those who live below it have many memories of it and tales to tell. Anecdotes of how fast one could drive up it and learning to drive on it are just some of them. (Marcia Darby.)

On the Cover: In 1954, downtown Lewiston is all decked out for the annual Lewiston Roundup. Since 1935, there has been a rodeo parade with the queen and her court riding their horses, the Lewiston High School (LHS) Bengal Claws precision marchers, flag twirlers, the LHS Band, floats, and the cowboys and Indians making it a great celebration. (Bill Gropp.)

IMAGES
of America

LEWISTON

Jeri Jackson McGuire

ARCADIA
PUBLISHING

Published by Arcadia Publishing
Charleston, South Carolina

Library of Congress Control Number: 2017947671

For all general information, please contact Arcadia Publishing:
Telephone 843-853-2070
Fax 843-853-0044
E-mail sales@arcadiapublishing.com
For customer service and orders:
Toll-Free 1-888-313-2665

Visit us on the Internet at www.arcadiapublishing.com

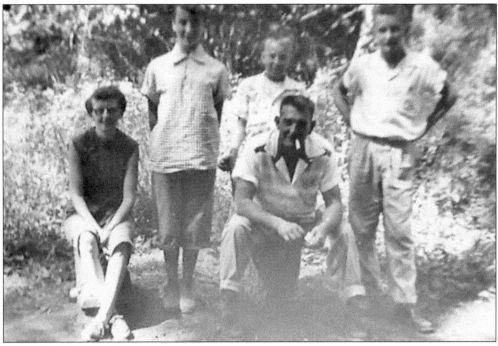

This book is dedicated to my parents, Dile and Freda Jackson, and my brothers, Bob and John, without whom this story could never have been told. My dad always said that we lived in God's country here in the Pacific Northwest. He used to say it was so beautiful that you had to drive through some ugly states just to get to the beauty of Idaho and Washington. I miss my family and thank them for all the strength and love they gave me. From left to right are Freda Jackson, Jeri Jackson, Bob Jackson, and John Jackson, with Dile Jackson kneeling in front. This image was captured around 1955. (Author's collection.)

CONTENTS

ACKNOWLEDGMENTS

I would like to express thanks to my title manager, Angel Hisnanick, who was a joy to work while writing this book about my hometown. I am also indebted to Arcadia Publishing for accommodating me in getting this book to market. (I had two major surgeries and had to keep pushing back the publishing date.) This book could never have been completed without the excellent help and assistance of Mary E. Romero of the Nez Perce County Historical Society and Museum in Lewiston. I would like to thank her for the great amount of assistance she gave me—researching, enlarging, and keeping me on track and for being so generous with her knowledge of Lewiston and its surroundings.

Special thanks go to Dick Riggs for his invaluable help in keeping me on track as well as to my lifelong friend Mary Bauman for loaning me her precious photographs for the book and for all her "inside" information. Big thanks go to Ron Karlberg, Bill Henley, Bill Otten, Rosalie Thomas, Dave Berman, Dana Rae McKay Williams, Bill Lintula, Judith Geidl, Don Perkins, Phil Stonebraker, Russ Mason, Penny Banks, Suzi Harootunian, Steven Branting, Brianna Jackson, Nez Perce County Historical Society and Museum, Asotin County Historical Society, and Bill Gropp (for the cover photograph). When I put a call out for pictures, many contributed. I appreciate it so much.

Special love is extended to my great-grandchildren Zadie and Xavier McGuire, Alexis and Mia Vazquez, and Carson and Rhyan Sanders. I want to thank Ron and Teri McGuire; Matt and Herta McGuire; Brandi McGuire; John, Kim, and Brianna Jackson; Dani, Kip, Kade, and Sarah Andrus for their constant encouragement, and last but not least, I would like to thank my husband, Jim, who is always there and gives me the help and support I need—especially to get through this year.

INTRODUCTION

I was born in Lewiston, Idaho, on a hot summer day in July 1942 at what was then St. Joseph's Hospital, a year after Pearl Harbor, where my uncle Walter Ebel had died on the USS *Arizona*. My grandmother Frieda Ebel was a gold star mother.

In the 1940s, my mom met my dad when she was working at Niggs, a candy store, in downtown Lewiston. Military men were everywhere in Lewiston and spent their time off blowing off steam, as they were stationed in surrounding small towns. My dad was one of those guys in uniform who flooded the town and helped Lewiston have the reputation of being a wild place.

I started St. Stanislaus School in 1946 and went eight years until 1956. Then our class traveled to the old Lewiston Junior High building next to Lewiston High School. Kids came from all the elementary schools—Webster, Warner, Orchards, Garfield, Weaskus, Tammany, College Elementary, and Whitman—and we all met at the Lewiston Junior High. It was an exciting experience.

Potlatch Forests Incorporated (today called Clearwater Paper), was the largest white pine mill in the world and it was a mainstay for Lewiston's economy. People from Lewiston and Clarkston and the Orchards and East Lewiston worked there, and most stayed there until they retired. It was a pulp and paper mill and give off terrible odors. "The smell of money" is what everyone called it. One time, there was an inversion over the valley, and it held in all the smoke from the mill. The aftermath was that all the houses that had lead in their paint turned black. We would walk to school and count the houses that it had affected. My mom had an old silver teapot, wrapped in "Sarah warp" (Saran Wrap was new then), that turned black. We never thought what it might be doing to our lungs. I did not realize until I was an adult that three top employees of Potlatch Forests Inc.—Robert Bowling (who invented Pres-to-Logs), Robert Billings, and Homer Hubenthal—lived on the same block as we did.

Farming and agriculture became the main staples for the economy after the gold rush was over. I grew up when the Lewiston Orchards was not part of Lewiston. I had some aunts and uncles who lived up there. We would go visit them and see the rows and rows of fruit trees that were the orchards back then.

Most of the businesses and buildings that I remember from my youth were built in the 1940s: the Roxy, the Liberty, and the Granada Theaters, Jack's place, Golden Grain Dairy, M&K, and Holsum Bread. The Brier Building, the tallest building in town, and the Weisgerber Building, with the Owl Drug on the corner of Fifth and Main, were mainstays of Lewiston. Many of us had appointments with dentists that were in those buildings, and the experience was not pleasant. This was before high-speed drills and local anesthetics. A lot of us were "gassed" the old-fashioned way and had silver fillings. The Brier Building and C.C. Anderson had the only elevators in town, unless you count the freight elevator at Lewiston Furniture.

Of course, living near two rivers, the water became a big part of our life. I have memories of log drives, the river turning to ice and flooding and pushing bridges. We did not have much in the way of entertainment in those days, so anything like a big piece of ice trying to push a bridge away was very exciting to us.

It was a time of walking to school, having neighborhood grocery stores, as families only had one car and the mother usually did not work. We kids got to walk to school, walk downtown by ourselves during summer, and play outside in the dark. We saw the first supermarkets when Albertsons and Safeway came to town. Most people had gardens then.

We learned to drive at 14 and had our driving lessons on the Lewiston Hill. All the guys had a car or wanted one. Guys were considered cool just by the cars they drove. When the drive-in theaters opened with "buck night," all of us piled into the backs of pickups, with some in the trunks of cars, just to get in and see our friends. We went to the annual rodeo and the Bengal Claws LHS marching group marched behind the horses, which pooped, during the parade.

Baseball, sports, fishing, boating, water-skiing, camping, slumber parties, and summer adventures made every day a new day, each one bursting with possibilities.

Most of us grew up without watching TV until our teen years in the 1950s. Not everyone could afford a TV and those that did would have "new" friends coming by to see theirs. Television shows were black-and-white and screens had a test pattern when the station went off at midnight. Most of the people who had television received it from the cable that came from Spokane, Washington. Later, KLEW-TV began and was our local station. It took a few years to get color television. It took more for the remote to be invented.

The telephones hung on the wall, usually in the kitchen, where everyone in the family could hear your conversations. Telephones had a curly cord where it would stretch and you could walk away and have a little privacy. We talked to an operator and had two-digit phone numbers, party lines, dial phones, and finally, push-button phones. Teenage girls especially loved the new Princess phone.

The Lewiston Mall (Center) opened in 1967. The first store to open was Kinney's Shoe Store, in August 1965, and PayLess Drug Store followed the following month. Buttrey's grocery store opened the following day, and Montgomery Ward, Grants, Tempo, and Centre Restaurant opened soon after the grand opening on September 29. They had about 850 cars in the parking lot. Across the road, McCann's barn was demolished, the gulley was filled in, and a Kmart was established.

I am getting ahead of myself and need to concentrate on the years prior to my birth. Imagine my surprise when I learned that on July 13, 1925, Walt Disney married Lillian Bounds, a lady who had moved from Spalding, Idaho, to go to the Lewiston Business College. Years later, I learned they had stayed at her brother Syd's house at 918 Third Street, which was just around the corner from where I lived all those years later.

Lewiston came to be because gold was discovered up the river near Pierce. Adventurers and gold-seekers came to the region and found that the area that would become Lewiston was a good place to pitch their tents. From that beginning, along with all those people, Lewiston was a wild city with shootouts, prostitutes, and gambling. There are many books that go into more detail about the earlier years. This is a thumbnail history of the town that focuses mainly on the 1950s. Unfortunately, there is not room to name everything and everyone. I hope you enjoy this trip down memory lane.

One

NO PLACE FOR A LADY

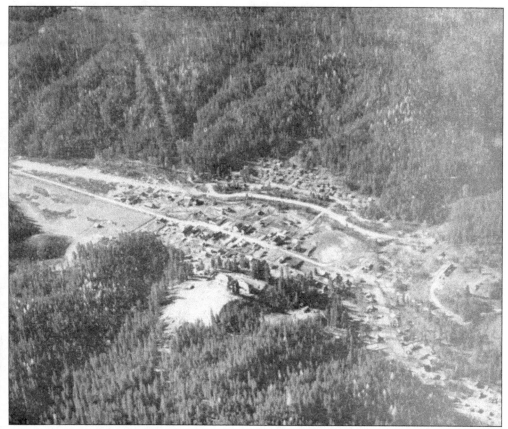

E.D. Pierce was the true "father of Lewiston." He discovered gold in Canal Gulch in the fall of 1860, and the town of Pierce was established at that site. By that summer of 1861, thousands of gold-seekers poured into the area, which would eventually become Lewiston. Pierce was just up the river from Lewiston, but E.D. did not visit it much and he eventually ended up broke. (*The Golden Road To Adventure*, 3rd ed., 1947.)

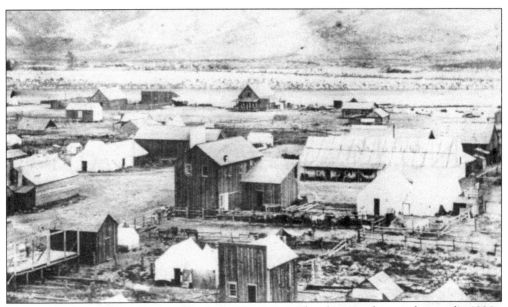

This is one of the oldest pictures of downtown Lewiston. The photograph was taken in the 1800s. Lewiston was founded in 1861 and was initially a city of tents. They housed a shifting population of 7,000 to 8,000. One of the earliest tent buildings, constructed in March 1861, was a warehouse for mining supplies. The town was made up of mostly men. Women were in the minority and mostly "ladies of ill repute" who followed the men to the west. (Nez Perce County Historical Society and Museum.)

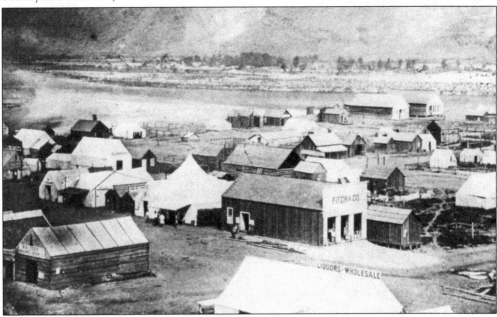

This photograph shows the right half of the picture of Lewiston at the top of the page. It depicts various buildings with the Lewiston Hill in the background. The first settlers put up tents, but once wood became available in 1862, various buildings began to appear. Since Lewiston was no longer on the Nez Perce Indian reservation, the tents were soon replaced with permanent buildings. (Nez Perce County Historical Society and Museum.)

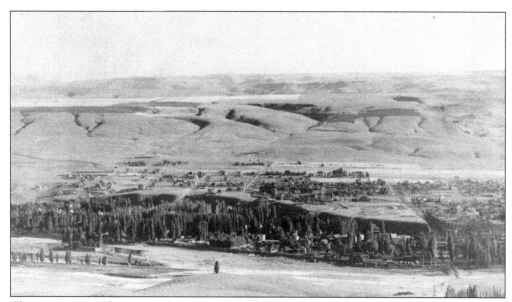

Those arriving and seeing early Lewiston in 1862 noted that it was situated at the junction of the Snake and Clearwater Rivers, with buildings and tents on the low bench on the bottomland. About 200 yards from where the steamer *Colonel Wright* landed, a widespread bluff could be seen. Tents were put up by partners Stephen Reuben, a Nez Perce headman, and retired mountain man William Craig, who was married to a Nez Perce woman. (Nez Perce County Historical Society and Museum.)

The Nez Perce (Nimiipuu) Indians owned the land where Lewiston was built. On November 18, 1895, the Dawes Allotment Act opened up the Nez Perce Reservation land for purchase by non-tribal whites, bringing 2,000 whites to acquire land. Because of the act, the Nez Perce, who originally had 700,000 acres, saw their land reduced to 7,000 acres and later to 70 acres. They moved from that land up the river to the towns of Spalding and Lapwai. That was to be their new reservation. (Kathy Kernan.)

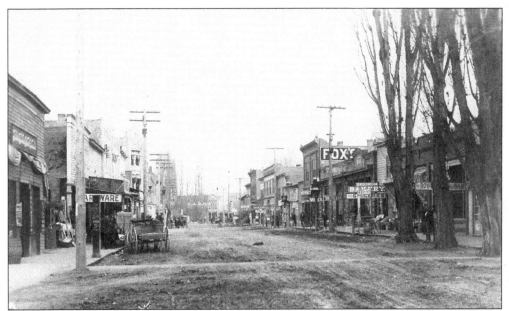

In the 1800s, Lewiston's population, later in the thousands, would consist of fortune hunters, thieves, robbers, murderers, and desperadoes, escaped convicts, along with Jewish merchants, German brewers, Mexican packers, Chinese miners, and support personnel who all flocked to the area. By that time, houses of ill repute, or bawdy houses, were plentiful. Lewiston was so wild at the time that several settlers crossed the Snake River by ferry to settle Jawbone Flats, the land that would later become Clarkston, Washington. (Nez Perce County Historical Society and Museum.)

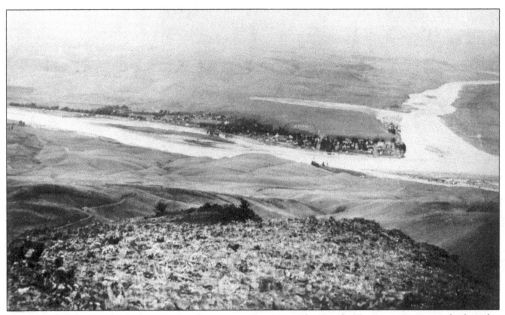

Lewiston, Idaho, and Clarkston, Washington, just across the Snake River, were named after the famous explorers Meriwether Lewis and William Clark. In 1892, the first newspaper, the *Lewiston Teller*, began publishing when Lewiston was still part of Washington Territory. (Nez Perce County History Society.)

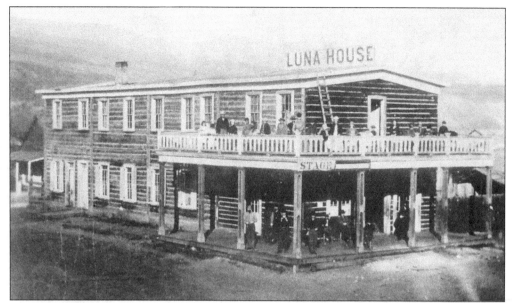

The Luna House was a hotel and stage office. In 1863, Lewiston was the first capital of the new Idaho Territory. The territorial seal and archives, stored in the Luna House, were stolen and traveled south to Boise. On December 7, 1864, a resolution was passed by the Idaho Territorial Legislature making Boise the capital. Many Lewistonians feel the capital was stolen out from under them. Meanwhile, Luna House owner C. Beachey brought to justice several killers who would otherwise have gotten away with murder. His close friend Lloyd Magruder had planned to travel from Lewiston and was killed along the way. The murders were brought to justice and hanged at Thirteenth and Idaho Streets. (Nez Perce County Historical Society and Museum.)

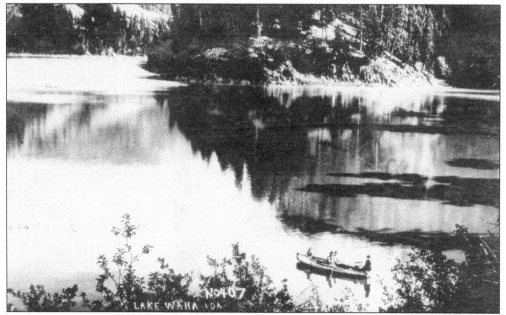

This 1900s photograph of Waha shows the beauty of the lake south of Lewiston. At the time, it was considered a great resort for boating and picnicking and many Lewiston residents and their families made the daylong trip up there to enjoy its beauty. (Dana Rae McKay Williams.)

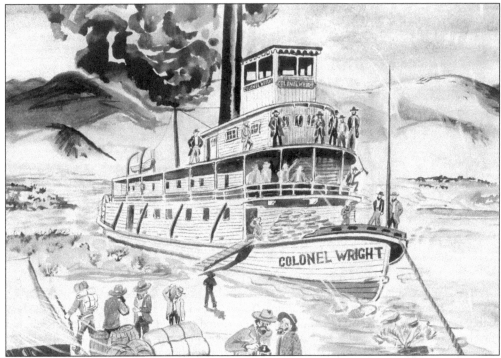

In the 1800s and 1900s, supplies for the new town came from Portland via riverboat. The first riverboat, the *Colonel Wright*, was tested on the uncharted Snake River and also tested 22 miles up the Clearwater River. Another boat, the *Okanagan*, reached from Portland via the Columbia River and then had to go overland nearly 200 miles from The Dalles, Oregon. (Nez Perce County Historical Society and Museum.)

This photograph, taken in 1896, shows Freida and Charles Ebel, who homesteaded in Genesee from Berlin, Germany, and who later moved to Lewiston. Charles sits with his wife on his lap, and a "ghost" lady on the right shakes her finger at them. The ghost is actually his wife, whom he put into the negative. Charles had an early interest in photography and did "Photoshopping" long before that application was invented. (Author's collection.)

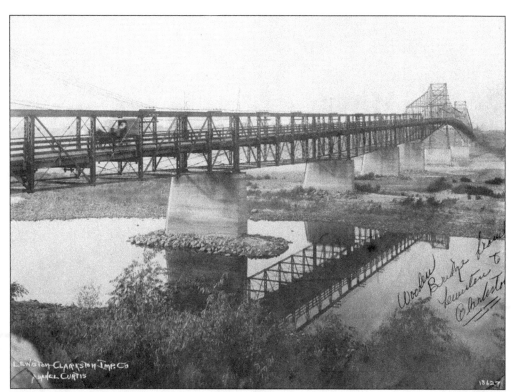

This is the Concord Bridge, which opened on June 24, 1899. It was the first toll bridge between Lewiston and Clarkston. It was built at an eastern foundry and was originally intended to span a river in Argentina, but a South American firm canceled the order. At a total cost of $110,000, an extension on the east end was provided so that it would fit the beautiful Snake River location. (Asotin County Historical Society.)

This photograph was taken in the 1800s. It shows the difficulty of building the Fifth Street Hill from downtown to the top. Workers had a steep hill, plus mud, rain and more to deal with. Lewiston was expanding with homes on the hill, and another route was needed. At the time of this photograph, the workers are shown playing at being "robbed" by their fellow companions. (Asotin County Historical Society.)

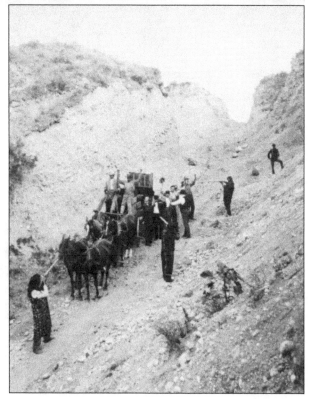

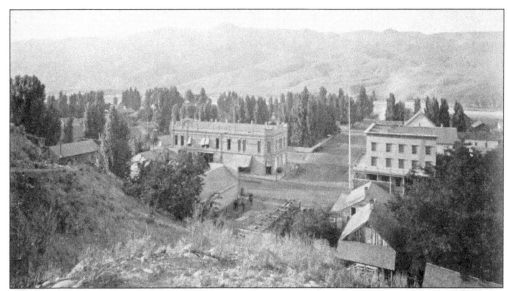

The street view of downtown Lewiston taken from Pioneer Park in the 1800s shows what downtown Lewiston looked like before the Fifth Street Hill was finished. The new street would make it much more convenient to get to what was becoming the residential part of the town. (Nez Perce County Historical Society and Museum.)

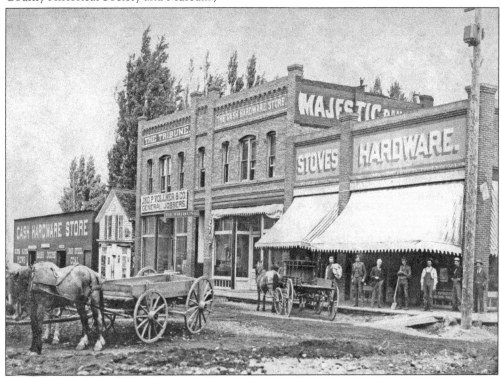

The award-winning *Lewiston Morning Tribune* was first published by Eugene L. Alford and Albert H. Alford on September 29, 1892. It has been bringing news and information for over 125 years. The building at Fifth and D Streets was originally Cash Hardware, which later became Erb Hardware. It is now Lewiston's new library. (Nez Perce County Historical Society and Museum.)

Two

THE WAY WEST

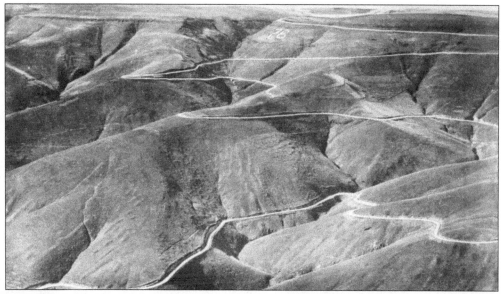

By 1900, it was evident that a new road up the Lewiston Hill was needed to connect to the north and south communities. C.C. Van Ardsol, one of the founders of Clarkston, Washington, made it a reality. He had experience with several railroads and a number of highway projects. The hill was an eight-mile road with 60 dangerous switchbacks and returns. The project was completed in 1917. (Nez Perce County Historical Society and Museum.)

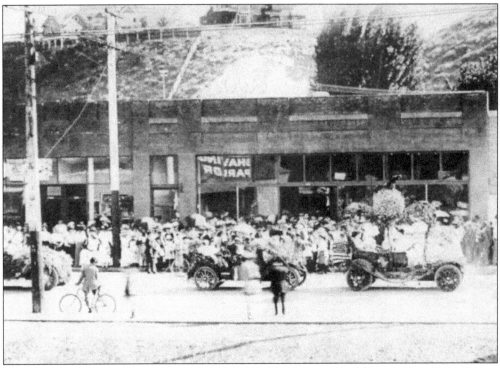

This shows a downtown Lewiston parade in 1912. The Largent Building, at 1100 Main Street, is on the right behind the parade. (Largent's and the Nez Perce County Historical Society and Museum.)

After the gold rush in the Lewiston area in 1861, agriculture had been what kept the city going. Thousands of settlers came and laid claim to 500,000 acres that were ceded by the Nez Perce Indians. Homesteading by the white settlers meant the economy of Lewiston and Clarkston would be measured by the wheat they grew and sold. (Author's collection.)

Early 1900 grain-harvesting operations took place locally and in surrounding areas, like Genesee, Idaho, as shown in this picture. Sixteen-hour workdays and 60-day harvest seasons were not unusual. Farmers began to organize cooperatives in 1930. Lewiston Grain Growers was incorporated and later consolidated with other area of cooperatives in order to improve services. (Author's collection.)

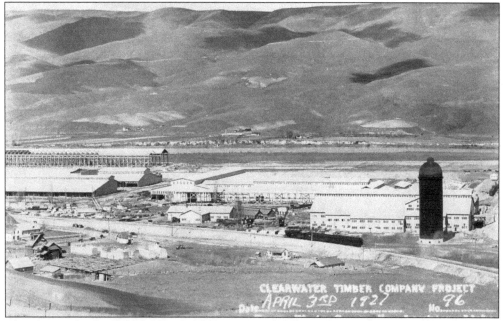

This is an early photograph of Potlatch Forest Incorporated. The paper mill provided many jobs for people of the valley. It is said to be the cause of the failing of the Clarkston Orchards, as the farmers discovered they could make more money at the mill than farming. Because of the smelly odors associated with the mill, it caused many to refer to it as "the smell of money." (Nez Perce County Historical Society and Museum.)

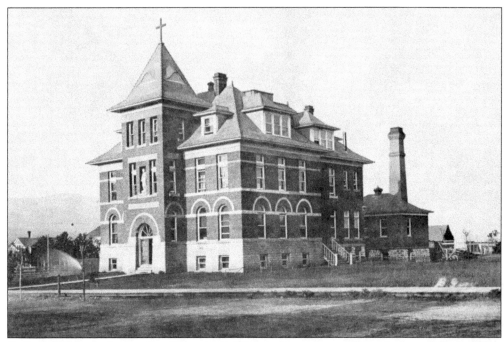

St. Joseph's Hospital started on February 8, 1902, in a seven-room frame house on Snake River Avenue. It later moved to Normal Hill, where it has since expanded into the St. Joseph Regional Medical Center, at 415 Fifth Street. (Nez Perce County Historical Society and Museum.)

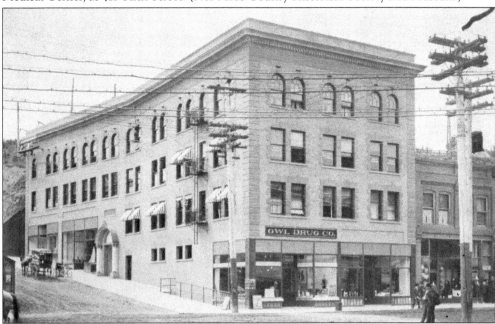

The Weisgerber Building was built in 1905 and was located at the corner of Fifth Street Hill and Main Street. It housed offices and the Owl Drug Co. The building burned down on March 1, 1994. For 12 years, that empty lot was a sad reminder of what was lost, including the memories. It was replaced by student housing for Lewis-Clark State College in 2006. (Nez Perce County Historical Society and Museum.)

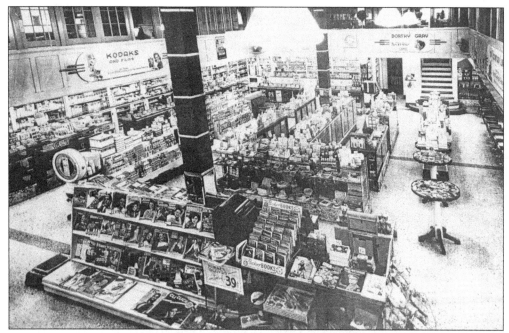

This is a 1940 picture of the inside of Owl Drug, which was on the ground floor of the Weisgerber Building. It was always a popular place to shop. It had everything one could need, from picture developing, filling prescriptions, and eating a sundae on the counter to buying lipstick or a popular "potion" of the time. (Nez Perce County Historical Society and Museum.)

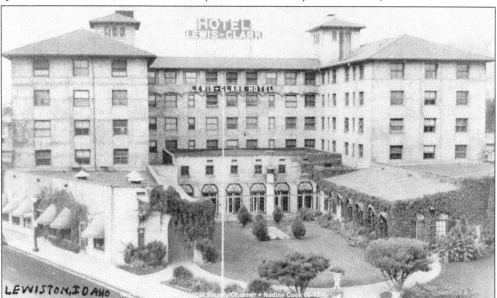

The Lewis-Clark Hotel is the jewel in the crown of downtown Lewiston. In 1919, business leaders hired Kirtland C. Cutter, a Spokane architect, to design the building. On September 28, 1922, the hotel opened with two days of festivities, including a parade. Many leaders of the town were part of its coming into being. Many memories of dinners, dances, and celebrations are part of the town's reminiscences. The hotel itself closed to overnight customers in 1977, but it is still used for weddings and such. (Nez Perce County Historical Society and Museum.)

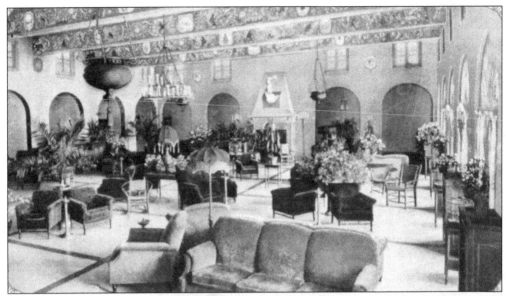

This c. 1922 photograph shows the elegant inside of the new Lewis-Clark Hotel. The gracious public spaces, including the ballroom and former Victory Room, continue to accommodate public and private events. It was designed by Kirtland Cutter and was the finest building in Lewiston. (Nez Perce County Historical Society and Museum.)

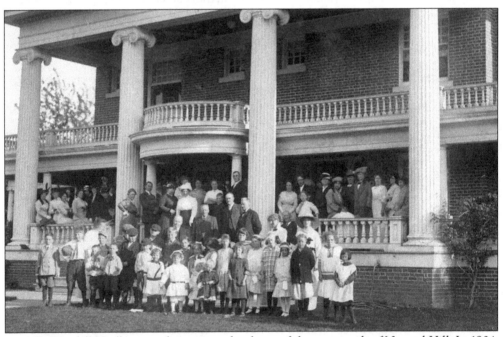

In 1899, Wendell Hurlbut was the primary developer of the area south of Normal Hill. In 1904, he commissioned Kirtland Cutter to design a grand mansion for him. Three years after he left Lewiston in 1909, the Children's Home Finding and Aid Society purchased the building referred to as the Children's Home. In 1968, after 50 years of service to thousands of neglected children, it closed. (Steven Branting Archives.)

This photograph was taken in 1909, the year Lewiston's Union Depot was built at 030 Main Street, at Thirteenth Street. The coming of modern transportation around the Union Depot in 1915 not only brought travelers to Lewiston but also brought along investors wanting to attract tourists to the fishing, hunting, and impressive scenery of the area to make more profit. (Nez Perce County Historical Society and Museum.)

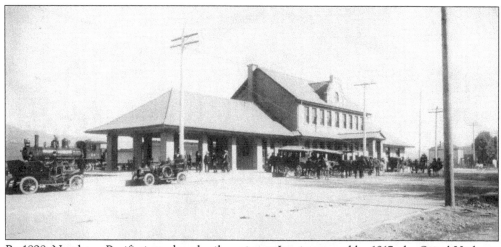

By 1898, Northern Pacific introduced rail service to Lewiston, and by 1917, the Spiral Highway was completed, winding 2,000 feet up the grade to the north and adding another route for transportation. The coming of modern transportation around the Union Depot in 1915 made these moving connections important. The Lewis-Clark Hotel was built in 1922 to serve as a social and business center for all the people coming to the area. (Nez Perce County Historical Society and Museum.)

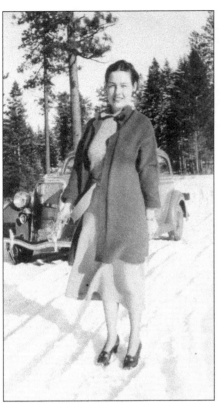

Enjoying the snow is a young Margaret Lindsey. She and her fiancé, Glenn Bauman, were taking a day-trip to Waha in his new Packard sedan in the 1930s. She later married Bauman, the manager of Lewiston Furniture Company. They had three daughters—Mary Catherine, Sally, and Florence. Mary still lives in Lewiston. (Mary Bauman.)

The Raymond House, shown in 1909, was built around 1879 at Fifth and Main Streets. It was one of three leading hotels in the Lewiston at the time. Fire damaged it in 1922, and the hotel was rebuilt and renamed the Raymond Hotel. It was a stage stop and later became a bus depot. It was torn down in 1962 to make way for a parking lot. (Nez Perce County Historical Society and Museum.)

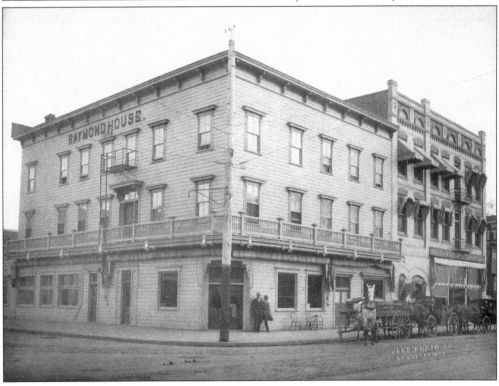

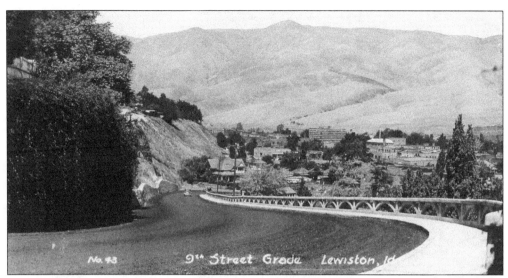

Pictured here around 1935 is Ninth Street Grade. It was originally constructed in 1902, when an alternate route was needed to the Normal Hill. By 1927, Normal Hill citizens were complaining about Fifth Street Grade, which was in rough shape, and they wanted a new road. Years later, in 2005, the railing and arbor were repaired. The workers designed them to meet current standards while retaining the architectural style of the old one. (Ron Karlberg.)

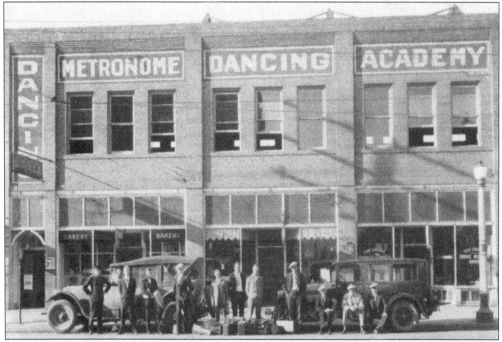

The Metronome Dance Academy opened in 1912. It was on the top floor of the building at 848 Main. In 1919, Hayden Mann and his brothers played there for dances on Saturday nights. Much later, it was bought by Pat Patroy, who made it a current popular dance place in the 1960s. Patroy named it Casey's, after his son. He brought in the Kingsmen, Roy Orbison, and Paul Revere and the Raiders before they were famous. It was $1.25 to get in and dance to their music. (Nez Perce County Historical Society and Museum.)

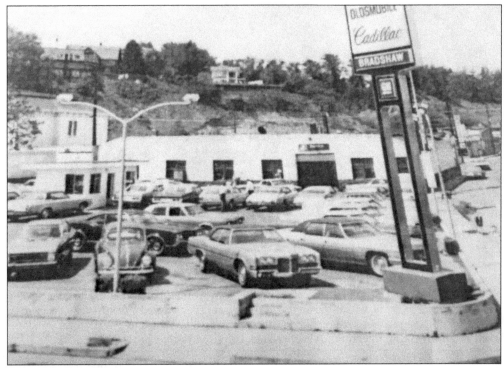

This is the Bradshaw Oldsmobile dealership in 1959 at Tenth and F Streets in Lewiston. The business was at this location from 1961 to 1981. (Norma Bradshaw and Nez Perce County Historical Society and Museum.)

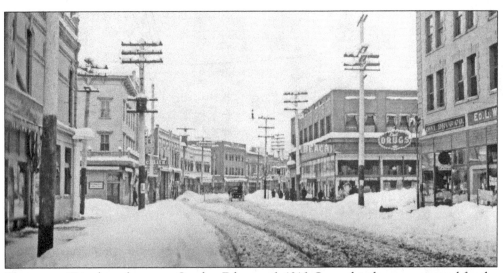

There were 28 inches of snow on Sunday, February 6, 1916. Snow this deep was unusual for the valley at that time, and Main Street looks deserted. In the view looking east, one can see the Weisgerber Building on the right and the C.C. Anderson store straight across Fifth Street. (Nez Perce County Historical Society and Museum.)

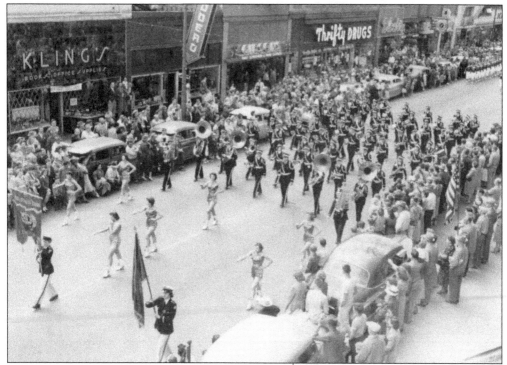

Seen here at Ninth and Main Streets, this parade took place in 1928. On the left is the popular Klings store. People loved walking down Main Street and going into Klings to get a bit of the Karmelkorn inspired by the recipe from Angie Galano's. The store carried a wide variety of art supplies, books, and beautiful things that were on display. (Nez Perce County Historical Society and Museum.)

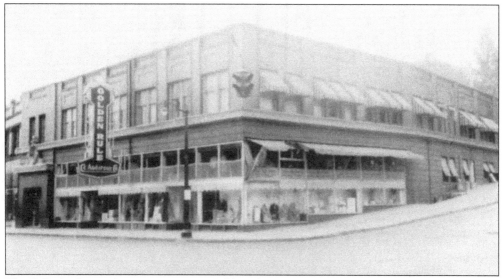

The C.C. Anderson department store at Fifth and Main Streets was a very popular place to shop. It had everything from dishes to shoes to prom dresses to Boy Scout uniforms. It was originally the R.C. Beach store and was owned by John Vollmer. It later became a Bon Marché and has since been remodeled several times. (Nez Perce County Historical Society and Museum.)

Otto Lukenbill worked as a camp cook for the Clearwater Timber Company on the North Fork and also on wanigans in the late 1920s. Otto was the husband of Laura (Merril) Lukenbill. She later moved to Lewiston and was a seamstress for the hat shop on the north side of Main Street. She always lived in various upstairs apartments downtown, including above the Majestic Café. (Bill Henley.)

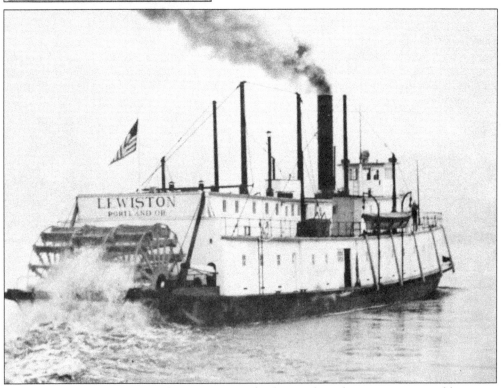

Carrying passengers up the Snake River, stern-wheelers, such as the *Lewiston*, were able to pass under the bridge. It made shipping easier, bringing goods and people to the area. As other means of transportation became more popular, the *Lewiston* was one of the last stern-wheelers to pass under the bridge. (Asotin County Historical Society.)

Three

TAKE ME HOME

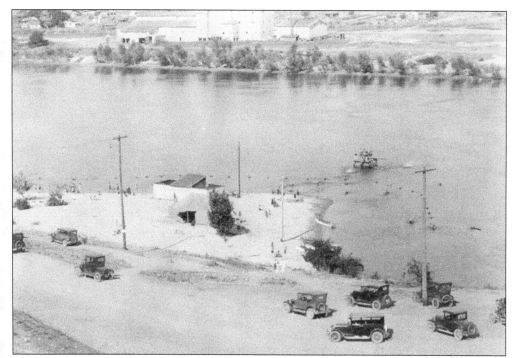

This Clarkston Beach photograph was taken around 1929–1930. The beaches are in the foreground just beyond the diving board and the tower. Lewiston Beach can be seen across the river. This photograph was taken in the early 1930s, before the permanent facilities had been constructed. (Nez Perce County Historical Society and Museum.)

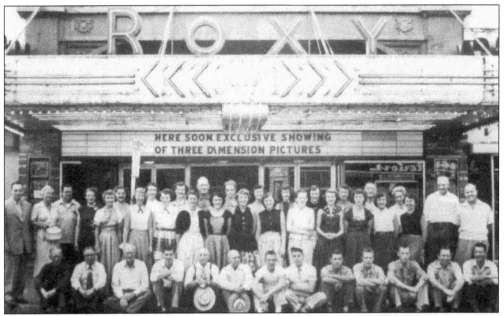

This theater officially became the Roxy in 1929. Before that it was called the Theatorium. It was one of three theaters in town in the 1950s, along with the Granada and the Liberty. In 1935, the first woman on the board of directors of independent theater owners of Idaho, Washington, and Alaska was Mildred Wall. (Nez Perce County Historical Society and Museum.)

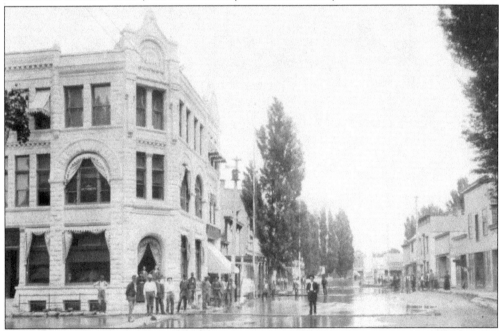

In 1894, Lewiston flooded. The roads turned to rivers and people had to get around with rowboats. The building on the left is the old Lewiston National Bank. It was built with sandstone, found in a quarry near Upper Asotin Creek. The building at Fourth and Main Streets was torn down and replaced with a modern bank and Tomlinson Black Realty. (Nez Perce County Historical Society and Museum.)

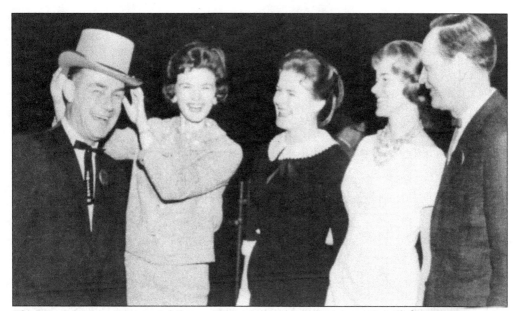

The Miss Lewiston Centennial Queen, Cheri Berg, places the hat on Gov. Robert Smylie in May 1961. Looking on are, from left to right, centennial princesses Judy Pederson and Linda Berg and Mayor Marvin Dean. (Judy Pederson.)

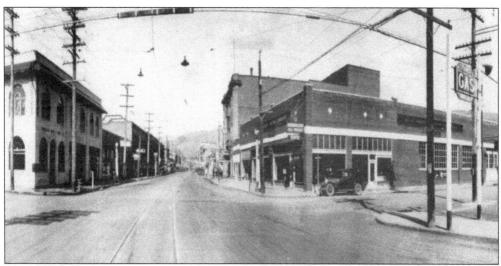

The corner of Ninth and Main Streets was a busy one. The Carssow Building on the left was erected in 1927, and the main floor has always been a bank. In 1928, Willett Brothers occupied the building on the right. One can see the trolley tracks that operated from 1915 to 1929 in the center of Main Street. (Nez Perce County Historical Society and Museum.)

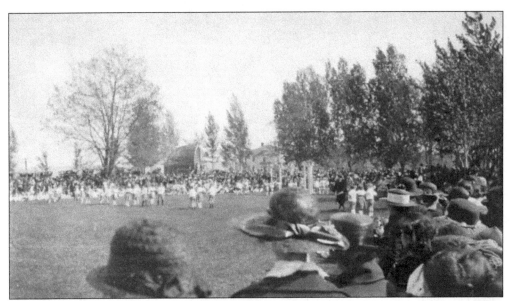

This is a family photograph from Kathy Kernan showing people at Pioneer Park. She does not know the history; however, it looks like it could have been taken at the time Pres. William Howard Taft visited Lewiston in 1911. (Kathy Kernan.)

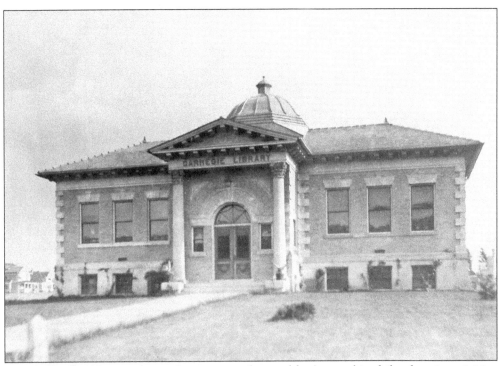

In 1901, Andrew Carnegie started giving away his wealth. Among his philanthropic activities, he funded the establishment of more than 2,500 public libraries around the globe, and Lewiston was the recipient of one. Lewiston's library was built in 1901 and is located on a hill overlooking the town of Lewiston in Pioneer Park. It closed in 1999. The site offers a great view of the Snake River and Clearwater River valley. (Nez Perce County Historical Society and Museum.)

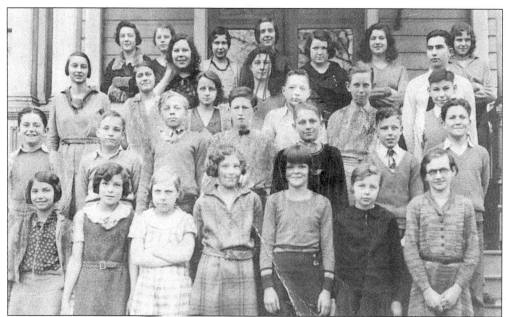

Students in this c. 1931 photograph from St. Stanislaus School are, from left to right, (first row) Jean Helen Bershaw, Dorothy Nuttman, Anna De Vault, Margaret Gregory, Joan Gasser, Elizabeth Flerchinger, and Patricia Coffee(?); (second row) Bernard Hayes, Francis Stenstrom, Hubert Flerchinger, Robert Bowling, Ambrose Malerich, Vincent Bostin, unidentified, and Vincent Lavory; (third row) Helen Garby, Angeline Thoma, Alice Le Voey, Freda Ebel, Catherine Bowling, Lawrence Hall, Joseph Hall, and Paul Brynes; (fourth row) Myrtle Williamson, Maxine D?, A. Flynn, Barbara Fleckerneger, Betty L., Mary Evangeline Anderson, and Frances Gregory. Ambrose Malerich stands behind Lawrence, Joseph Hall in back of Lavory, and Paul Brynes in back of Barton. (Author's collection.)

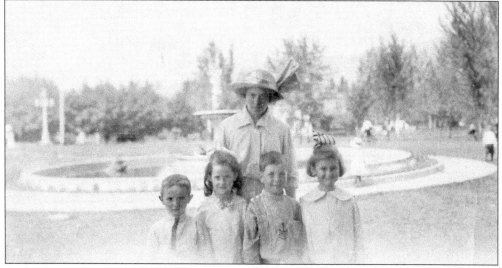

In this August 23, 1911, picture of Pioneer Park, Marcia Howell is shown with her students, from left to right, Jack Jennings, Sara Mae Crum, John Erhardt, and Janet Black, enjoying the new fountain that was the centerpiece of the park. There was also a band shell in the park. Prior to being a popular park, it was a cemetery. (Nez Perce County Historical Society and Museum.)

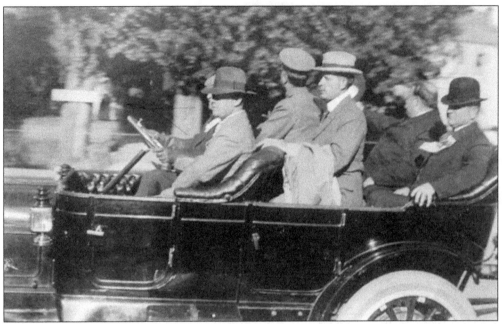

President Taft (back seat, left) visited Lewiston on October 7, 1911. He arrived by train and then was driven in a car owned by Mayor Louis J. Perkins, who is seated in the back seat with the president. They are on their way to Pioneer Park for Taft to deliver a short address. (Don Perkins.)

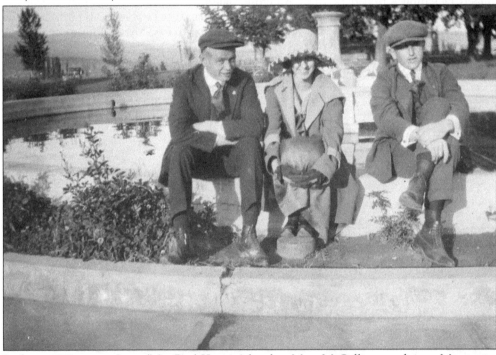

In this c. 1911 picture, Irene (Mrs. Ray) Kernan's brother, Marx McCallister, and sister, Marguerite (center), are sitting with an unidentified friend. Pioneer Park was a place to go on Sundays. People were usually all dressed up for a walk after church. It was also used for picnics, celebrations, and special events. An Easter egg hunt was held each year with a golden egg as the prize. (Kathy Kernan.)

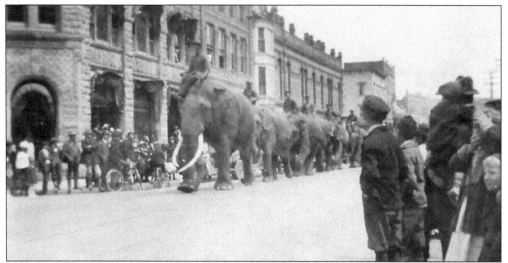

On August 9, 1928, the circus came to town with a parade of elephants. It was always an exciting event, but this time five elephants panicked. They broke loose from the circus where they were staying on Snake River Avenue and raged down to C Street and on to Fifth and Main Streets through the town and residential area, smashing things and terrorizing citizens. (Nez Perce County Historical Society and Museum.)

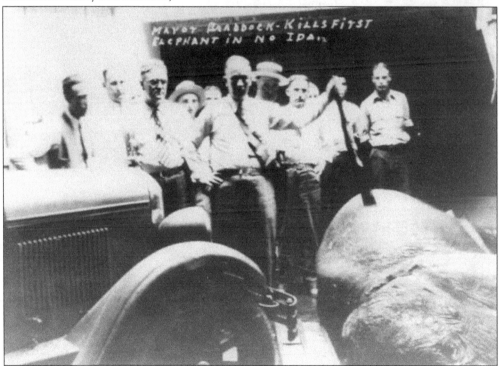

On August 9, 1928, Mary, a circus elephant, went on the rampage on Main Street in search of water. She knocked out storefront windows and damaged vehicles. Finally, Dr. E.G. Braddock, the mayor, brought his big game rifle to the location and shot the elephant. Dr. Braddock had her foot made into an end table. Her hide covered a sofa in the doctor's lounge, and her trunk is displayed in a private collection. (Nez Perce County Historical Society and Museum.)

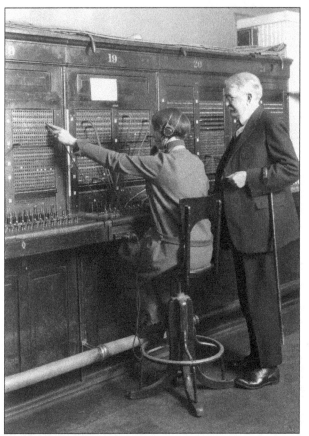

The first patent for the telephone was in 1875 by Alexander Graham Bell. Although they popped up all over the country in a year, telephones appeared slowly in Lewiston. Early 1888 residents complained that the lines were so low, they posed a danger to men on horseback. Pacific Northwest Bell later moved to 0203 Third Street. Here, a Mrs. Wilson demonstrates the operation of a switchboard to A.H. Alford. (Nez Perce County Historical Society and Museum.)

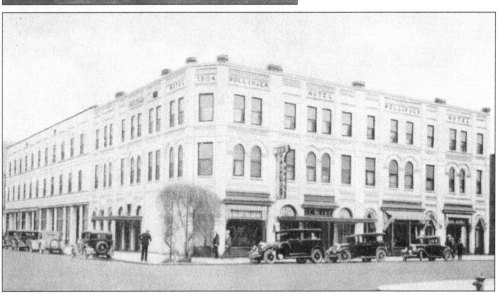

The Bollinger Hotel was built in 1898 in stages and was completed in 1904. It was considered a leading hotel of northern Idaho and located at Third and D Streets. The Bollinger had a very popular cocktail lounge. In 1977, it was remodeled and became the Bollinger Plaza, only to burn down on June 18, 1997. (Nez Perce County Historical Society and Museum.)

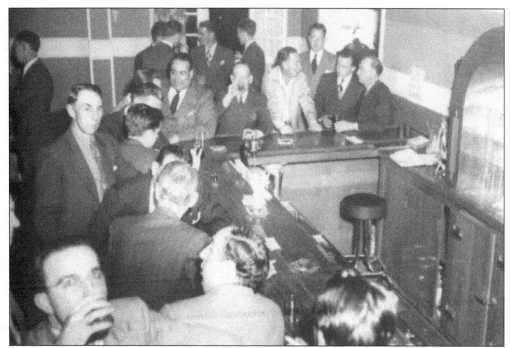

Lewiston had a long history of bars, drinking, and gambling. In 1950, most of the hotels had bars and cocktail lounges. The number of liquor licenses was a lot more than allowed per population. The licenses were legal as they were able to be grandfathered in. (Nez Perce County Historical Society and Museum.)

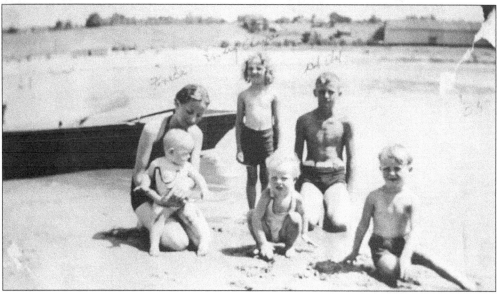

Lewiston resident Freda Jackson is shown with family members at the Clarkston Beach in 1935. She is holding niece Charlotte Kernan, with, from left to right, her other niece Mary Clare Kernan (standing), nephew Fred Kernan, brother Bob Ebel, and nephew John Kernan. (Author's collection.)

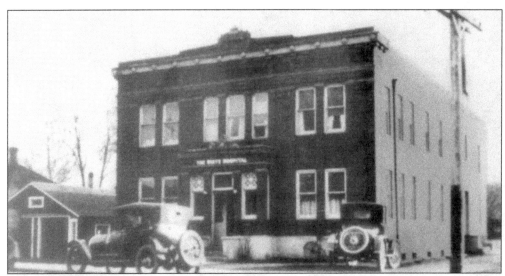

The White Hospital was built in 1916 by Dr. Edgar White. It was located at 1504 Main Street and had 32 beds, as well as operating and delivery rooms. The hospital was closed in 1946 due to a severe shortage of nurses. Unfortunately, like other older buildings, the White Hospital was torn down. (Nez Perce County Historical Society and Museum.)

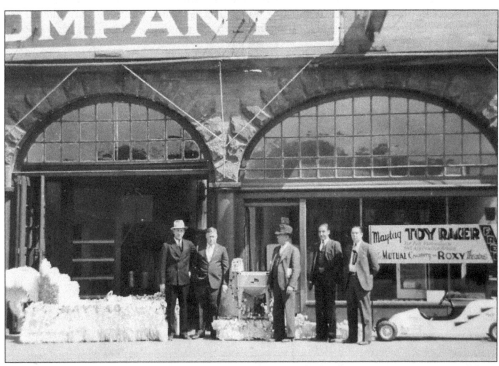

This picture, from the mid-1920s, shows the front of the Mutual Creamery, in the 1100 block of Main Street (where Ralph Largent got his start). Largent is at far left. They had just started bringing appliances into the creamery to sell. In 1930, Largent bought out the appliance section of the creamery and it then became Largent's. (Largent's.)

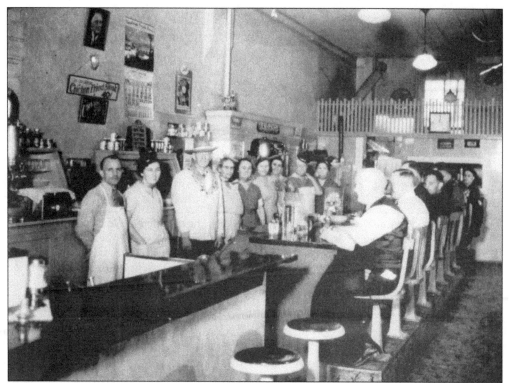

This is Del's Café at 324 Main Street in Lewiston during the Depression era. The employees had western hats because it was during the Second Annual Lewiston Roundup. Pictured behind the counter are, from left to right, Jackson Anderson, Viola Parks, Del LaBlanc, a Mrs. LaBlanc, Tussy, Happy Thomas, unidentified, a Mrs. Drumm, and Beulah Waite. The owners were Parks and Minnie Clift, who bought the café in 1937 and operated it until 1952. (Nez Perce County Historical Society and Museum.)

Don Dickamore's drive-in on Eighth Street was a popular place for treats and groceries. Former Lewiston resident Ginger Brodin recalls when she was a teenager and a soda jerk there, a black man came in and ordered "chocolate malt." She could not understand what he was asking for. (Lewiston had only one black person at the time). Finally, Dickamore noticed. Later, she found out the black man was Reggie Jackson. He played on the Broncs farm team before he became famous. (Lewiston High School Publications.)

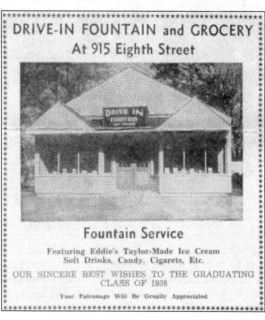

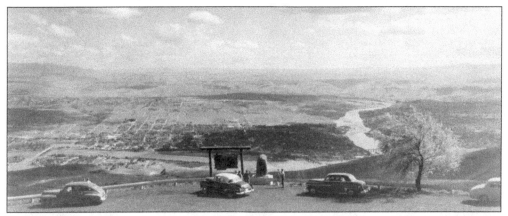

Travelers stop and admire the view before they drive down the treacherous old Lewiston Highway. When relatives of some people in Lewiston would visit, they would wait at the top of the hill for their families to come and drive them down the hill. On the other hand, students at Lewiston High School remember the thrills when they took their driving lessons on the hill. (Nez Perce County Historical Society and Museum.)

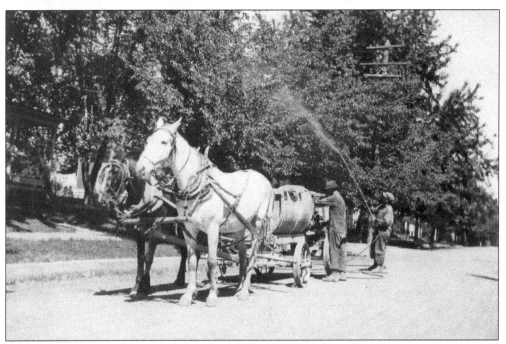

Ray Kernan is shown spraying trees on Normal Hill in Lewiston while working for the City of Lewiston around the 1920s. He was a former Idaho state conservation officer. His brother was Earl Kernan. Ray and Earl both had brides named Irene. The families lived in Lewiston. (Kathy Kernan.)

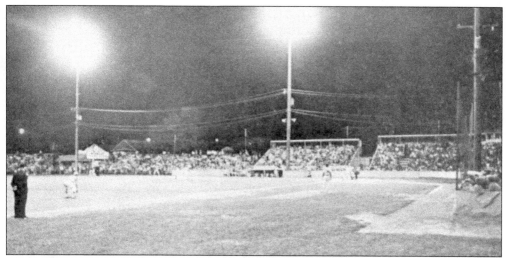

On April 20, 1937, Bengal Field was built. Twelve lights were attached to each of ten 85-foot cedar poles. This made is possible for Lewiston's first professional baseball team, the Lewiston Indians, to play night games. The Indians were part of the Western International League. Sadly, they finished last in the new league after losing 23 games. (Nez Perce County Historical Society and Museum.)

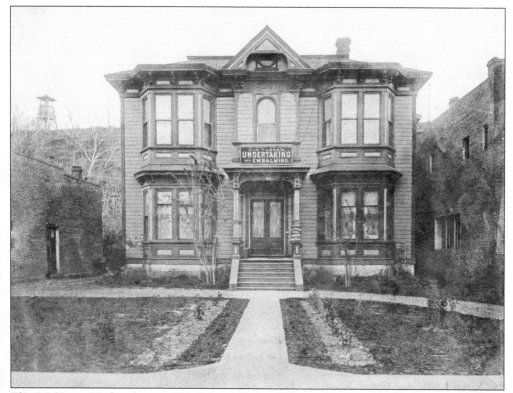

The C.J. Vassar Undertaking and Embalming Funeral Home at 608 Main Street is pictured around 1915. It is one of the oldest family-owned businesses in the Lewis-Clark Valley. The funeral home was first established around 1900 by Joseph O. Vassar and his son Clyde J. Vassar, who came to Lewiston around 1898 or 1900. (Nez Perce County Historical Society and Museum.)

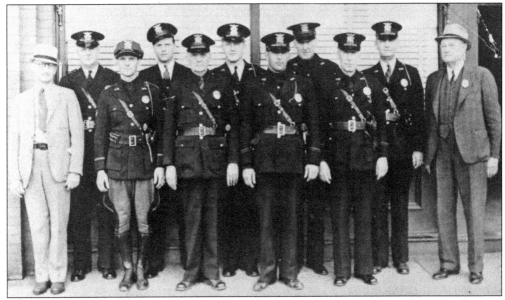

In July 1939, these men were the Lewiston Law Enforcement. From left to right are (first row) G.C. Sorey, police commissioner; Bud Huddleson; L.W. Pickering; Andy Verzani; C.H. Lee; and Eugene Gasser, chief of police; (second row) Jack Wrighter; Clarence Kyle; Ed Jacks; Yancey McNeil, assistant chief; and Homer Brutzman, night chief. (Nez Perce County Historical Society and Museum.)

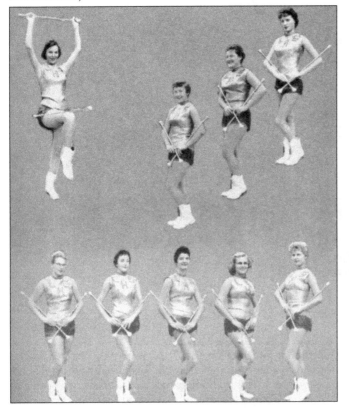

In the 1958–1959 school year, these high-stepping majorettes provided halftime entertainment for many football and basketball games. They are, from left to right, (top) Jerice Minnette (who led the majorettes), Sandra Nearing, Sharon McIntosh, and Rhea Jo Laird; (bottom) Barbara Jackson, Barbara Wolcott, Jeannie Windsor, Deanna Ryan, and Marilyn Angelo. (Lewiston High School Publications.)

Four

RAMBLING ROSE

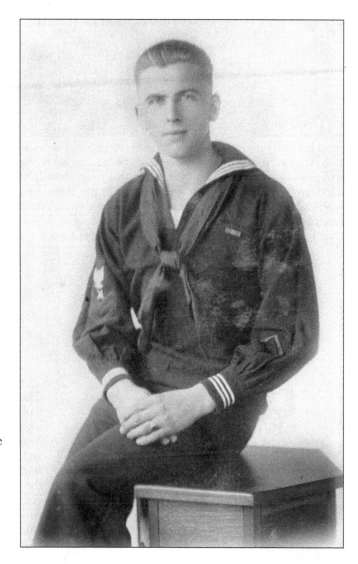

In the 1940s, Lewiston was becoming more agricultural and considering adding orchards to the city. Then the Pearl Harbor attack came on December 7, 1941. Walter Ebel was on the USS *Arizona* and killed during the attack. His mother, Frieda Ebel, lived at 613 Sixth Avenue and was a gold star mother, having three boys in the service at the same time. Many from Lewiston served. (Author's collection.)

In addition to agriculture, new businesses began out of necessity. Speers Bullet Factory started in 1943. Vernon Speer started building bullets because reloaders could not get the necessary machinery that was needed from ammunition companies. He eventually built the first mass-produced jackets handgun for law enforcement and hunting. In the 1960s, he put in loaded ammunition in the now-famous Lawman line. Like any good businessman, Vernon understood shooters' needs and reacted with quality products. The company was later bought by ATK and is now Vista Outdoors. (Nez Perce County Historical Society and Museum.)

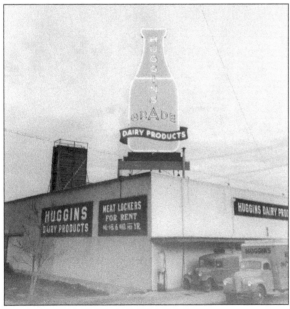

This is what the Huggins dairy looked like on May 5, 1942. It was located at Eighteenth and Main Streets, near Jack's Restaurant and Basil's Barrell. John Huggins started married life farming in the Lewiston Orchards and then eventually managed the dairy. Their children are Patricia and Richard Huggins. (Nez Perce County Historical Society and Museum.)

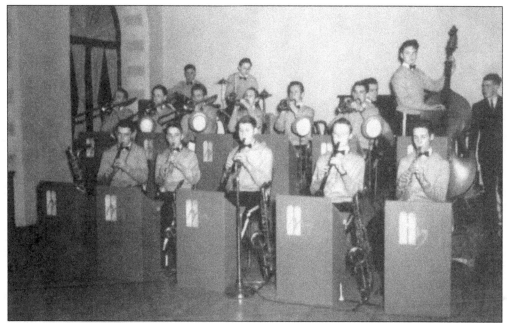

Students from Lewiston High School organized a musical group called the Melody Makers in 1942. Pictured from left to right are (first row) Ken McCormack, Don LeClair, Ken McIntosh, Bob Gilson, and Chuck Adams; (second row) Max Sorey, Bob Myers, Gene Brower, Bryan Hopkins, Bob Olson, Fred "Zig" Willett, and Don Holee (on bass); (third row) Claude Friddle, Bill Bond, John Caple, and Jack Hawkins. (Photograph by Bert Wilkins.)

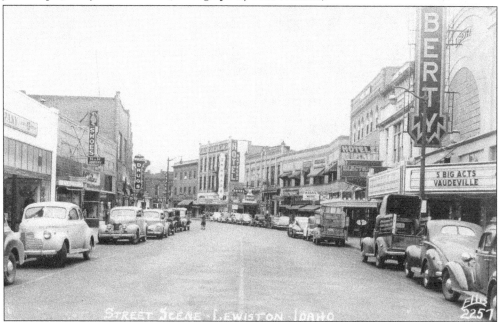

This is what downtown Lewiston's business district looked like in the 1940s, before television. Notice the Liberty Theater on the right. That was one of three theaters in town; the others were the Granada and the Roxy. For many people, it was fun to go to the movies, as they were always exciting. (Nez Perce County Historical Society and Museum.)

45

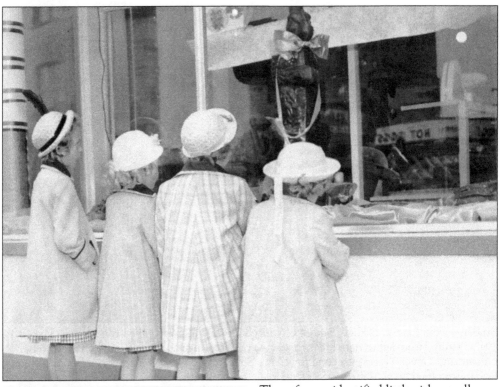

These four unidentified little girls are all dressed up in Easter finery and looking in the window of JoAnn's Candy. The store was located at 838 Main Street. (Nez Perce County Historical Society and Museum.)

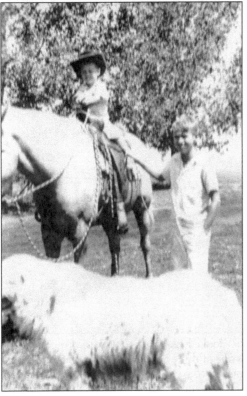

Phil Stonebraker is seen holding the reins of the horse with his sister Shelley upon it. Up front is Bo, their white Great Pyrenees, who was well known throughout the valley and beyond. Bo often hitched rides in cabs to Orofino, Anatone, and Lenore. There are many stories of Bo's adventures, usually with the owner, Merle Stonebraker, having to go pick him. Bo visited businesses and schools where the children loved to crawl all over him. (Phil Stonebraker.)

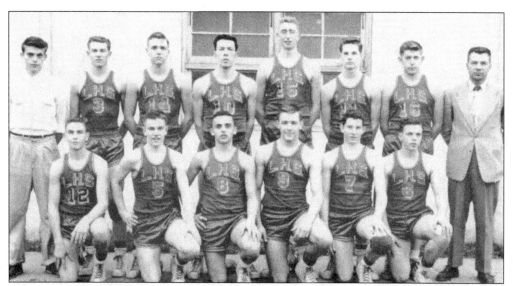

The 1954 basketball team won the runner-up spot to rate among the best LHS crews on record. Besides taking the state title, the Bengals ran up a 13-7 regular season record and won second place in the Inland Empire League. Players who would be lost next season would be Jim Brannon, Gary Chisholm, Doug Randall, Ed Campbell, Kent Patterson, Monte McMurray, and Virgil Wicks. Juniors coming back were Ellis Olson, Denny Bowling, and Dick Ruark, with sophomores Charles Norton and Dick McDonald. (Lewiston High School Publications.)

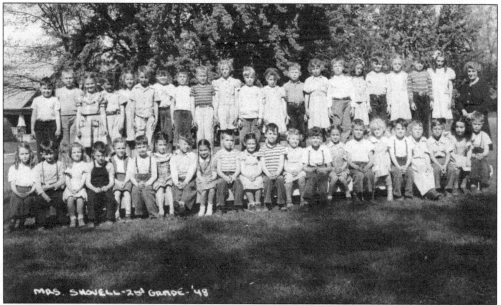

This is the LHS Class of 1957's second-grade picture, taken in 1948. The teacher is Josephine Shovell. From left to right are (first row) unidentified, Larry Brian, three unidentified persons, Caroline Ward, Jere-Rae Rasmussen, Vivian Cole, unidentified, Billy Hart, unidentified, JoAnne Janni, Janice Bethel, five unidentified persons, and Bob Davis; (second row) unidentified, Larry Stevenson, Ron Gustin, unidentified, Bob Lautenslager, John May, Gerald Louis Kight, Bobby Jones, Chester Peterson, unidentified, Mick Woodland, Gerry Dietz, Billy Henley, three unidentified persons, Glen Manwaring, and Shovell. (Nez Perce County Historical Society and Museum.)

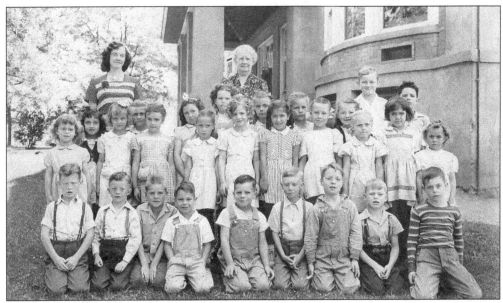

This is the first-grade class of Garfield School in 1947. Pictured are, from left to right, (first row) Melvin Rafferty, Percy ?, Ron McMurray, Benny Martin, unidentified, Marshall Harwick, two unidentified, and Steve Schaub; Gary Harvey is in the first row but is unidentified; (second row) Nancy Iverson, Nadine Riggers, Judith Geidl, Saundra Wagner, Janette Fosbury, four unidentified, and Janene Katzenburger: (third row) two unidentified, Jannette Fosbury, Patty Shomake, unidentified, Karen Sheneman, unidentified, John Rodeck, and Paul Knapp; (fourth row) teacher Miss Miler and principal Olive Vivian. (Judith Geidl.)

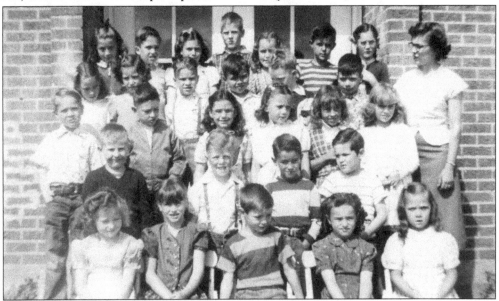

A Mrs. Graves (right) was the teacher of a combined first-and-second-grade class at Weakus School in North Lewiston, Idaho, around 1949. Identified are Gary Hibbein (second row, center, in suspenders), Jeaneanne Lukenbill (third row, far right), Billy Alspach (fourth row, third from left, in suspenders), and Joe Forkner (fifth row, second from right). Lukenbill was later married to Bill Henley. She passed away in 2016. (Bill Henley.)

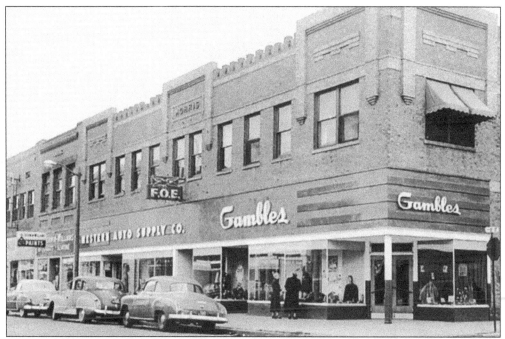

The Morris Building at New Sixth and Main Streets in Lewiston, shown here around 1951–1952, was home to many businesses in its time. Many of the old business names are great reminiscences along with the old-fashioned cars. This is now the site of Goicoechea Law Offices. (Linda Covey.)

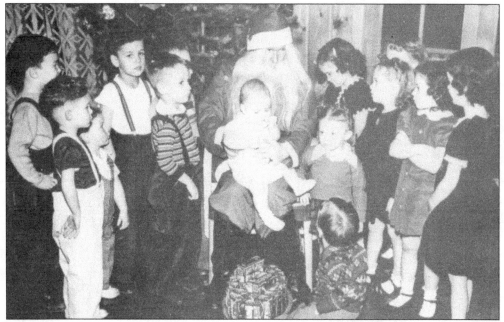

Waiting their turns to talk with Santa at the American Legion Christmas Party around 1949, in no particular order, are Larry Proffit, Bob Wise, Mark Wise, Garth Profit, Philip Stonebraker, Michael Bouton, Joan Bouton, Joan Mackey, Jan Rosholt, Betty Rosholt, Catherine Campbell, and Marcia Mackey. Santa and the baby are unidentified. (Nez Perce County Historical Society and Museum.)

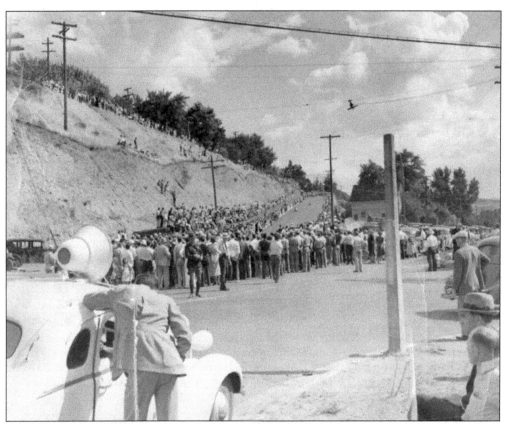

The Soap Box Derby was held on Main Street with the kids using Prospect Hill for the races. They drew quite a crowd. This photograph was taken around 1940–1949. (Nez Perce County Historical Society and Museum.)

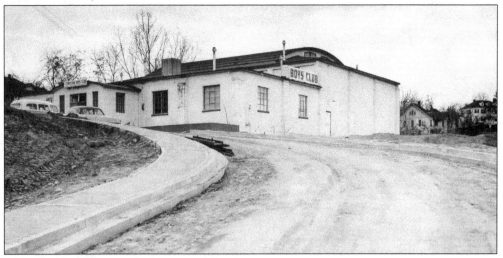

This is the new Boys Club building in Lewiston in 1959. The Boys Club was founded in 1945 with a membership of 85 members. That grew rapidly, and in 1948, a campaign was under way to fund a clubhouse at Vollmer bowl. A benefit golf match was played by Bing Crosby at the Lewiston Golf and Country Club in 1950. (Nez Perce County Historical Society and Museum.)

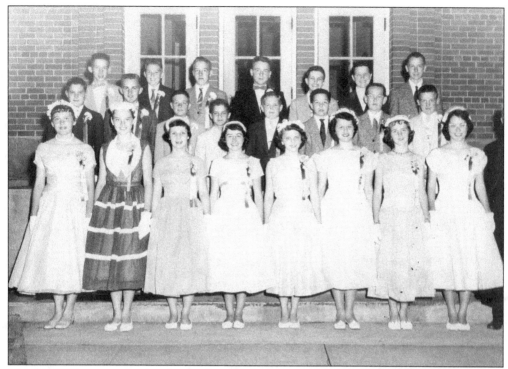

May 24, 1956, was graduation day for the eighth graders of St. Stanislaus Catholic School; they would become the class of 1960. Pictured here are, from left to right, (first row) Paulette Stonebraker, Mary C. Bauman, Anne Marie Funke, Suzi Harootunian, Betty Rosholt, Penny Hall, Jeri Jackson, Kay Jo Ranta, and Fr. Maurice Corrigan; (second row) Maurice Hoffman, John Jackson, Jim Bershaw, Dick Waite, Dick Vassar, Garth Profitt, P.J. Walker, and Don Marvel; (third row) Pete Gussenhoven, Charlie Schoenberg, Tom Kaufman, Bill Skelton, Wally Von Bargen, Jim Eisele, and John Barnes. (Author's collection.)

On August 16, 1948, Bing Crosby visited the unfinished Boys Club facility. Crosby was in Lewiston for a parade down Main Street and for a Boys Club golf tournament fundraiser. Assisting as self-appointed bodyguard, in white trunks, is Gary Henley, age 11, warning off troublemakers with a fierce look and superhero pose. It was rumored at the time that Henley left his little brother at home tied to a tree to avoid having to share the spotlight. (Bill Henley.)

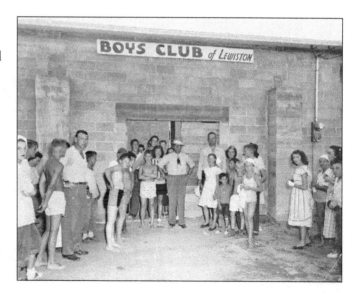

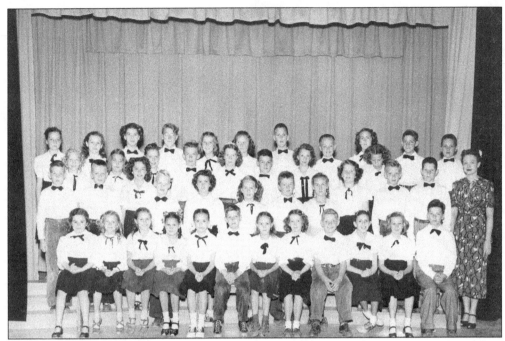

In this December 1948 photograph is the newly formed Whitman Grade School glee club of about 40 students, led by Jean Heitman, entertaining the Whitman PTA meeting. The glee club members, in no particular order, are Jerry Berger, Carla Bonner, Vivian Cole, Sharon Goucher, Bill Henley, Jeanette Howell, Margaret Huntley, Naomi Johnson, Gene Kinsey, Gerald Kight, Dick McDonald, Patty McKay, Norma Quigley, Joyce Rigg, Benita Schroeder, Carol Ann Torgerson, Dorine Baldwin, Doris Bonner, Shirley Condrey, Dale Deasey, Melvina Downing, Gary Henley, Monte Kress, Kay McKay, Dickie Phillips, Marlene Strickert, Dorothy Thomas, Neal Welker, Dan Willows, Delores York, John Bennett, Paul Barnes, Darold Burcham, Donna Lee Case, Ray Deasey, Floyd Evers, Judith Gerk, Deane Jacks, Sandra Kenworthy, Neal McCracken, Sharrol Olson, and Dickie ? (Bill Henley.)

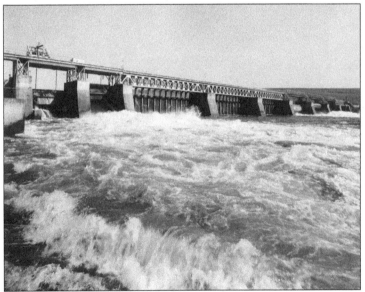

Clearwater Dam, with its water rushing through, was spectacular for all to see. The river was next to Highway 12, and at night, when the road was clear, hot rodders raced on it to the dam; they wanted to see, which car was more powerful and would win. It was a two-lane road and was scary and dangerous. (Nez Perce County Historical Society and Museum.)

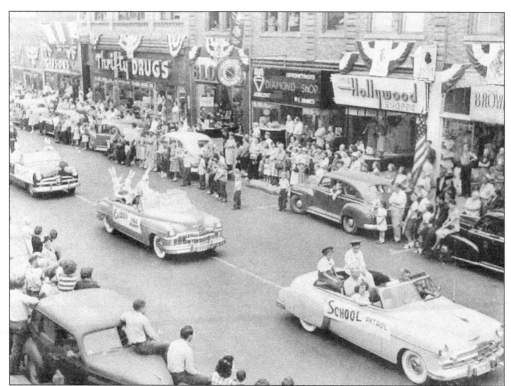

The Lewiston Roundup parade has been held since 1935. The parade traveled west on Main Street from the courthouse to the Lewis-Clark Hotel. Most businesses pictured on the south side of the 600 block of Main Street are no longer operating. (Linda Munson Covey and Nez Perce County Historical Society and Museum.)

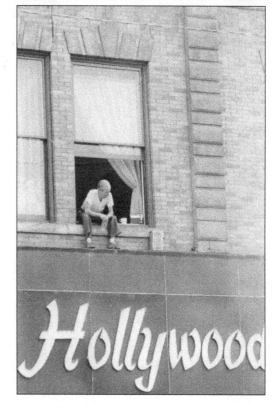

Lewiston is a town that loves parades. It looks like this man found the perfect place to watch them. Not everyone knew that there were apartments above some of their favorite shopping stores downtown. There were also "houses of ill repute" in some downtown apartments for years. (Bill Lintula.)

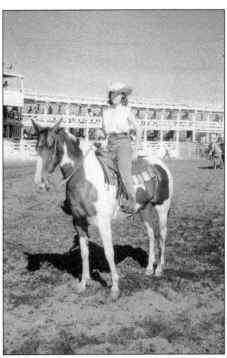

Rosalie Thomas is shown on her horse Skeeter at the Lewiston Rodeo Grounds in 1959. Thomas, a 1960 Lewiston High School graduate, was part of the Northwest Championship Junior Rodeo. (Rosalie Thomas Bruce.)

Queenie, Rosalie Thomas's Shetland pony, is shown in their house at 709 Airway Avenue in the Lewiston Orchards in the 1950s. All of the houses on that stretch of Airway were on an acre. Across the street was a Shetland pony ranch. There was a cherry tree farm on the other corner with delicious cherries, according to Thomas. (Rosalie Thomas Bruce.)

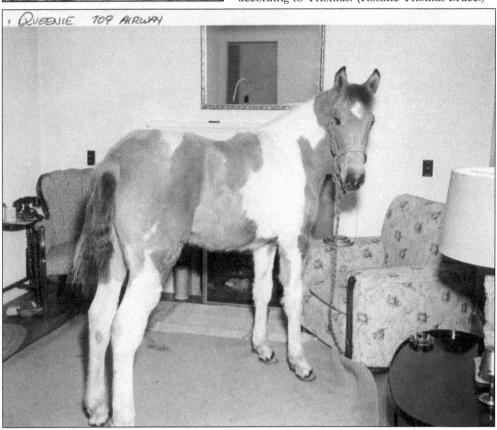

Spencers was a first-class restaurant in North Lewiston in the 1960s. It was known for its steaks, especially the bite-size steaks. It was the perfect place for wonderful food and to celebrate special occasions. The third lady from the left is John Vorous's grandmother Ava Lou Vorous. The other ladies are not identified. Other great places to eat were the Majestic Café and the Manhatten Café. (John Vorous.)

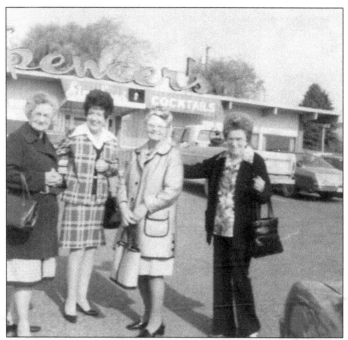

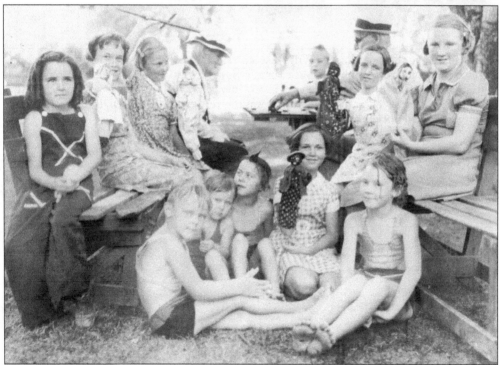

Pioneer Park was a fun place to play in the summer around the 1930s–1940s. It was cool and shaded and perfect for games. The children, in no particular order, are Andrew and Marguerite Setlow, Ann Conley, Pauline and Irene Zumalt, Catherine Mulroney, Phyliss Yenor, Lorraine and May Mulroney, Beverly Dewey, and Mavis Simpson; Harold Simpson, R.E. Draper, and P.J. Fleshman play checkers. One person is unidentified. (Nez Perce County Historical Society and Museum.)

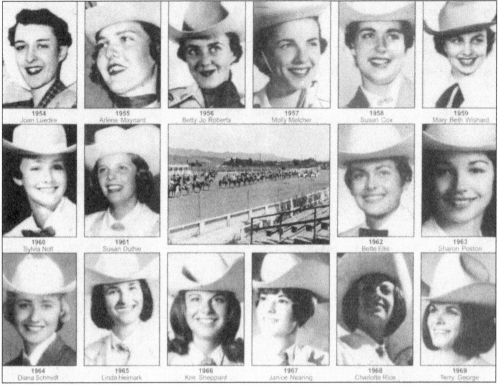

These ladies were the rodeo queens of the Lewiston Roundup when it as held in North Lewiston. Pictured on the top row, second from the right, is Susan Cox in 1958. In 1982, the property was sold to the Port of Lewiston. The rodeo moved to a new venue on Tammany Creek Road. Lewiston resident Dale Frost's mother, Dorothy Brock, was the very first rodeo queen, in 1935. (Nez Perce County Historical Society and Museum.)

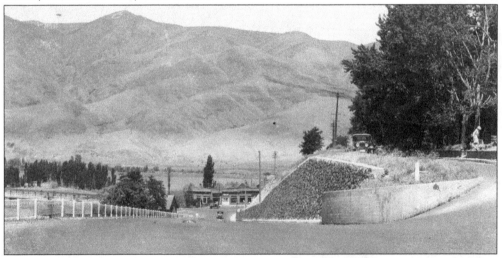

This photograph shows the top of Prospect Avenue, which travels down to meet Snake River Avenue and goes on into downtown's Main Street. The beautiful homes on Prospect Avenue have an ideal view of the Snake and Clearwater Rivers. (Nez Perce County Historical Society and Museum.)

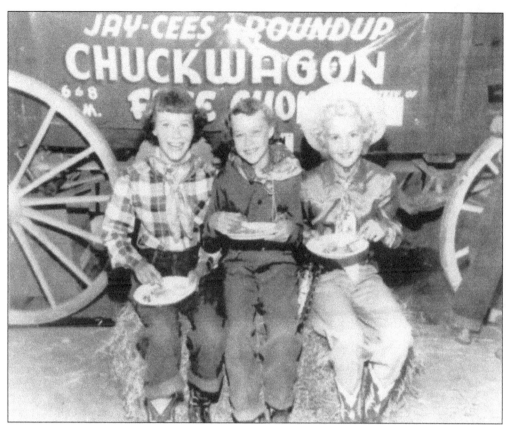

Enjoying the Lewiston Junior Chamber of Commerce free breakfast in 1950 are cowgirls, from left to right, Helen Jacobs, Connie Hamblin, and Dawn Fairley. The Lewiston Roundup was always a popular event, and kids always wanted to dress the part. (Nez Perce County Historical Society and Museum.)

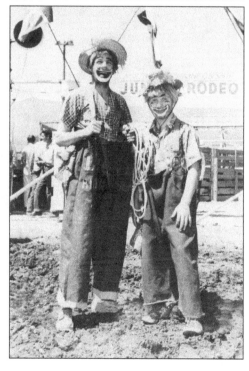

Dick Stelzmiller (right) says that when he was 12 years old, rodeo clown and family friend Lew Flora (left) asked if he would be interested in working with him in the junior rodeo program. Of course, Stelzmiller said yes. Stelzmiller says he did all aspects of the clown thing but soon recognized he was not a rodeo kid. They put him on a Shetland pony for the calf roping. Another event, calf riding, with the eight-second rule, was not his favorite. (Nez Perce County Historical Society and Museum.)

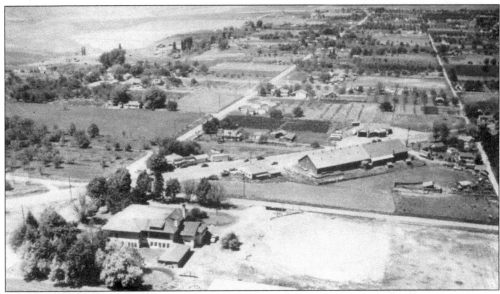

This is an aerial view of the popular Lewiston Orchards intersection at Thain Road and Burrell Avenue in 1945. At that time, the large building in the middle right of the picture was the cherry/lettuce warehouse. On the lower left, the large building was the old Orchards School, built about 1911. When the Lewiston Orchards were annexed by the city in 1970, the land's animal rights were grandfathered in. (Nez Perce County Historical Society and Museum.)

In this 1950s photograph are Ray Welch and his son Dave, who later became part of LHS's class of 1958. These were the early years in the Orchards, where the Welches had moved from Pennsylvania when Dave was around 10 years old. They farmed corn and had apple trees, goats, chickens, and cows. (Dana Rae McKay Williams.)

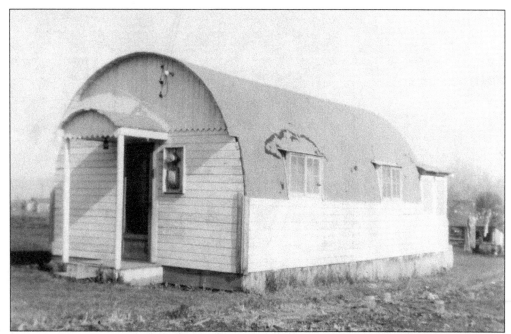

In the early years of the Orchards, this Quonset hut was used as a home for the Ray Welch family. The huts were very popular after the war and were often used for housing. Welch and his family lived there while they farmed in the 1950s. (Dana Rae McKay Williams.)

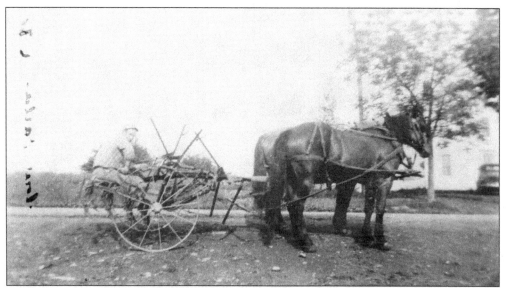

This photograph of Ray Welch shows him in the 1950s, on a wagon pulled by two horses at his farm in the Lewiston Orchards. He farmed until he started buying tractors and became a tractor mechanic. (Dana Rae McKay Williams.)

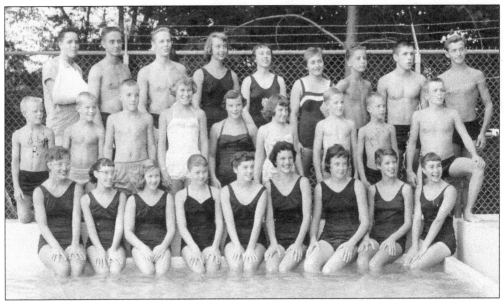

The swim team from Lewiston High School is pictured alongside the swimming pool in the mid-1950s. Pictured are, from left to right, (first row) Kay Ranta, Lynn LeFrancis, Roberta Sargent, unidentified, Marsha LeFrancis, Suzanne Klaaren, Colleen Mace, Glenna Gale, and Suzi Harootunian; (second row) Skip Pierce, John Vassar, Steve Arnold, Becky ?, Robin Shoemaker or Charlene Barton, unidentified, Bob(?) Vassar, John McKean, and George Gustafson; (third row) Dan Cole, Richard LeFrancis, Kurt Smith, Mary Beth Wishard, Janet Smith, Paula Harootunian, Art McKean, Lanny Watkins, and Ray Janni. (Art McKean.)

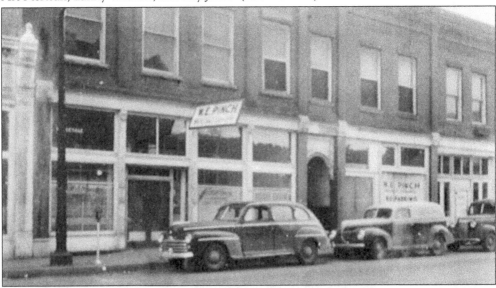

The W.E. Pinch confectionary store was located at 210 Main Street. The business was purchased in late 1920s by William E. and Anna M. Pinch, who ran it. What sustained W.E. Pinch for many years were the small businesses on the prairie. John Ruben "Jack" Pinch and his brother William Edward Pinch Jr. continued to deliver goods to the clients until the store's closure. The family honored their parents with gratitude right up until and including when the W.E. Pinch store closed its doors in 1998. (Nez Perce County Historical Society and Museum.)

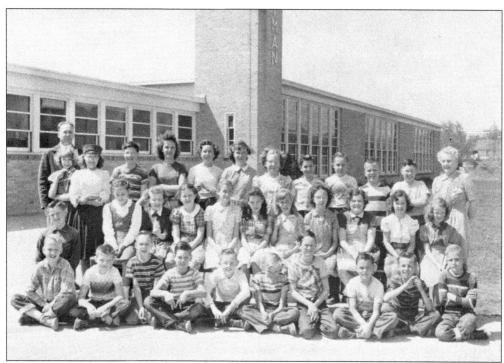

This is the "new" Whitman 5th Grade School in 1950. The teacher is a Mrs. Grant. Pictured are, from left to right, (first row) Bill Henley, Walter Broast, Mike Frost, Brian "Larry" Stevenson, Dick Ten Eyck, Ross Slacks, Bobby Edmonson, Johnny May, John Mahoney, and Kenny Reaves; (second row) Rusty Mason (kneeling), Madeline McKowan, unidentified, Jeanie Robinson, Joanne Janni, Mara Price, Sonja Wasink, unidentified, Sandra Ballard, Marie York, and Sally Burrows; (third row) Janice Bethel, Lorene White, Dick Hastings, unidentified, Joanne Strong, Jo Anne Jensen, Dee Herbert, Paul Barnes, James McDowell, Brian L. Fromdahl, Norman Spekker, and Mrs. Grant. Standing behind on the left is Wayne York, principal. (Bill Henley.)

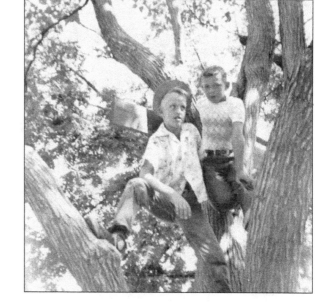

Here are Billy Henley (left) and his best friend, Kent Valley, in the Henley treehouse on Ninth Avenue in Lewiston. They lived in the same neighborhood and went to the same school all through high school and remain so. This image was captured sometime around 1951–1952. (Bill Henley.)

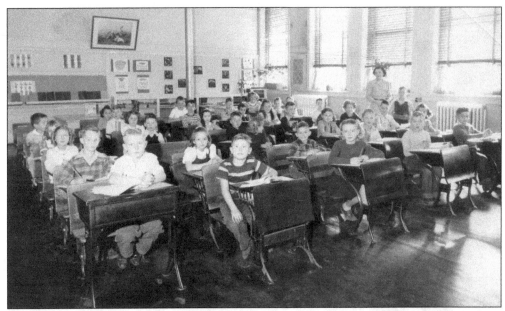

These are the children in the old Webster third grade—the class of 1957. They are, from front to back, (first row) Duane Ailor, David Nichols, and three unidentified; (second row) Peter Dole, Lovetta Drevlow, unidentified, Jeannie Robinson, Joe Dickeson, and Janice Smith; (third row) Linda Tull, Melvin Marvel, Sharon Longfellow, Ivan Davis, Marie York, Gerald Klemm, and Arthur Fry; (fourth row) Bob Williams, Paul Jacobson, Loretta Mael, Billy Rasmussen, Vondalee LaPlante, Billy Hart, and Amil Callahan; (fifth row) Lee Bernier, unidentified, Craig Whitcomb, Anna Lou Vanator, John Frazier, Paul Barnes (hidden), Sally Ruckman, and Janet Eier; (standing) Mrs MacKinlay and Paul Barnes. (Bill Henley.)

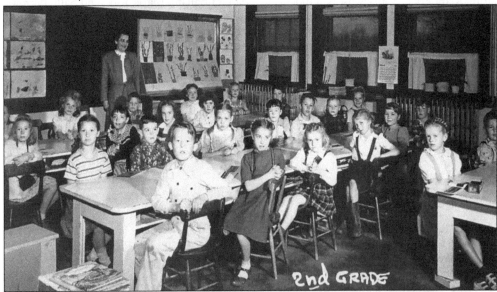

This photograph of the second-grade class was taken at the former Orchards Elementary School; the teacher was May Belle Smith. The school was located on the 1200 block of Burrell Avenue, near the site of the current school. (E. Joy Smith Forsman estate and Nez Perce County Historical Society and Museum.)

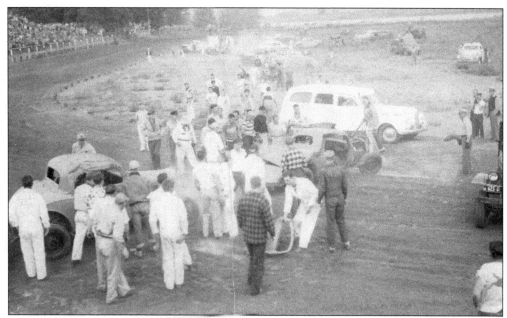

These stock car races were held in North Lewiston. Russ Mason went with his dad, Clark Mason, who took the 1950s photograph of the wreck that had just happened. (Russ Mason.)

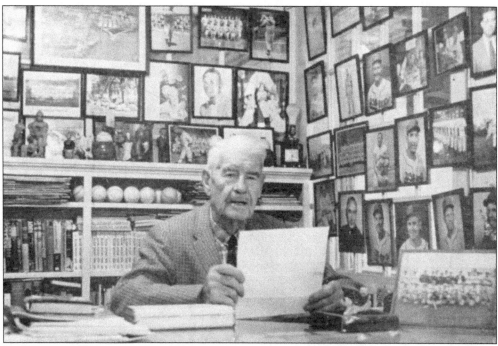

Dick Riggs comments on Loyd Harris, aka "Mr. Baseball": "In 1945 I played shortstop for our grade school city champion from Garfield School, and we were on Loyd Harris's KRLC radio show. Loyd asked me what I played and I said shortstop. Loyd Harris brought baseball to Lewiston. The best baseball player the valley ever produced was Vean Gregg in 1904." (Nez Perce County Historical Society and Museum.)

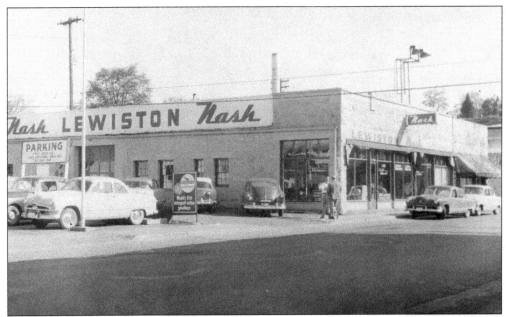

Tony Thompson bought the Nash/Rambler dealership sometime in the late 1950s. The address was 119 Ninth Street. In the 1970s, Thompson erected the building where Bob Jackson Body Repair is now located. Later, Thompson turned the Nash/Rambler business into a Datsun (Nissan) dealership, which moved to the Orchards sometime in early 1980s. (John R. Jackson.)

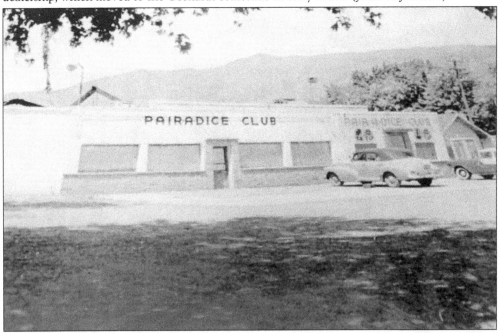

The Paradise Club was a lounge in North Lewiston in the 1950s. It and several others—including the Stables, the Arbor Lounge, the Golden Spur, the Stockman, and the Barge—were essentially places to go and have a drink and mingle. Friday and Saturday nights in Lewiston were always busy with patrons having good times and making memories. At this writing, Bojack's Broiler Pit is still going strong. (Nez Perce County Historical Society and Museum.)

In this c. 1951 photograph are Gary (left) and Kent Valley with a Cushman motor scooter in Bill Henley's backyard. The local kids had a lot of fun growing up in this neighborhood. (Bill Henley.)

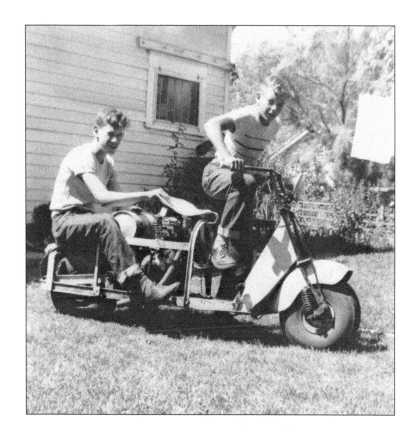

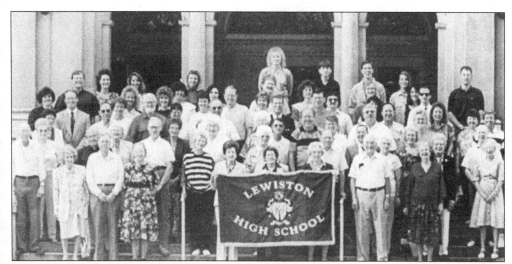

This iconic photograph, taken May 15, 1994, shows one person representing each graduating class at Lewiston High School from 1923 until 1994. All showed up for the picture except one person. The people are placed in no particular order. Madeline Von Bargen is seen at the front left, holding the flag. (Nez Perce County Historical Society and Museum.)

Students from St. Stanislaus Catholic School are shown in the gym balcony in this mid-1950s image. Pictured are, from left to right, (first row) John D. Jackson, Garth Profitt, Charlie Schoenberg, and Maurice Hoffman; (second row) Paulette Stonebraker, Karen Blewett, Karen Hoene, and Kay Jo Ranta. (Karen Hoene.)

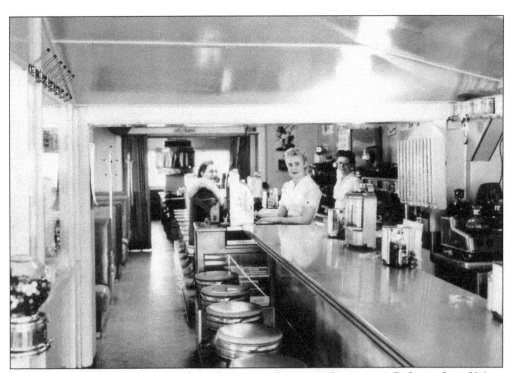

This is the interior of Jack's, a popular restaurant in downtown Lewiston at Eighteenth and Main Streets in the 1950s. In the back room behind the small curtain was a little monkey band that played tunes; it hung from the ceiling. Shown standing to the far right is Mona Mason Mercer, and the lady sitting at the counter is Betty Mercer. (Russ Mason.)

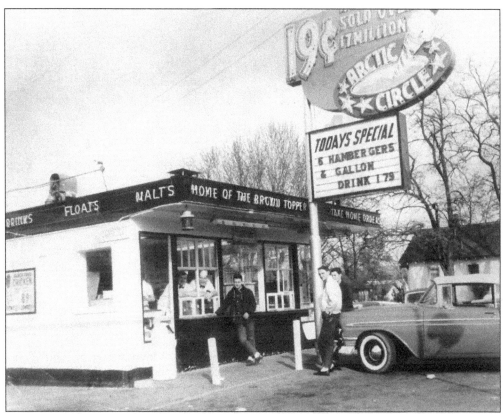

The Arctic Circle came to Clarkston in the mid-1950s. The prices were unheard of, with burgers being 19¢. People flocked to the first cheap fast-food restaurant in the valley. It became the place to go to get fries with the "secret sauce," circle dogs, and more. The customers are unidentified. (Author's collection.)

From left to right are Mona Mason, Elsie Nieman, Jack Shaunessy (owner of Jack's), and Barney Byers (Teamsters union representative) in the late 1950s or early 1960s. This event was the signing of the Teamsters contract, when the employees of Jack's voted to belong to the union. (Russ Mason.)

This is a picture of the Reno Addition in Lewiston, Idaho, in 1959. It was started by Henry Reno, who was a landowner, and more builders later constructed homes there. When the Reno Addition was built, it gave folks the opportunity to live in a lovely place where all the homes were new at the same time and with easy access to shopping. It is located near Southway Avenue and Eighth Street. This view looks west to Clarkston. (Asotin County Historical Society.)

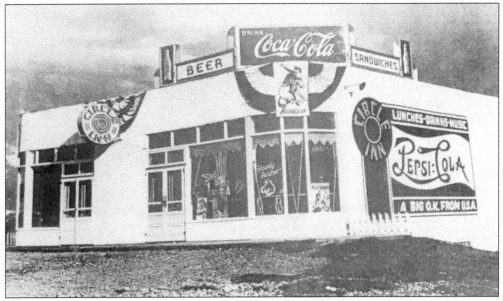

In 1940, Frank and Louisa Murphy built the Circle Inn near 2418 North and South Highway. The parking lot of the old Rusty's Ranch Cafe was where the building originally sat. The Murphys sold beverages and sandwiches. On December 6, 1965, it was torn down exactly 25 years to the day it was built. (Esther Louise Barton and Nez Perce County Historical Society and Museum.)

This is the Blue Bridge that connects Lewiston with its sister city, Clarkston, Washington. It was originally painted green and spans the Snake River between the two towns. The photograph was taken sometime between 1939 and 1959, it was taken from the Clarkston side of the river with a view looking east toward Lewiston. This span replaced the old Concord Bridge. (Nez Perce County Historical Society and Museum.)

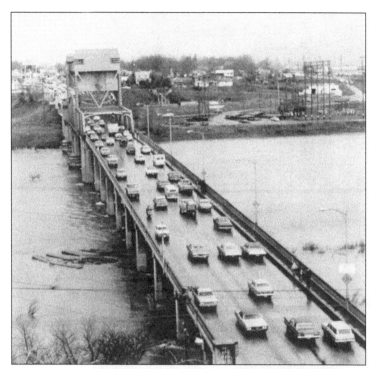

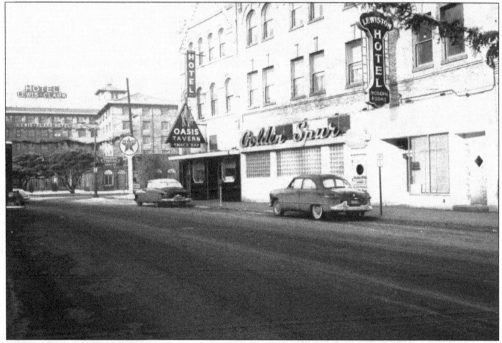

This was the entrance to one of Lewiston's local clubs, the Golden Spur, back in the 1950s. Tommy Thomas, then manager and head bartender, proudly displayed the club's theme on his car and on saddles. He commissioned Bill Whitney of the Diamond "C" Saddle Shop to make saddles for the winners of the Golden Spur Derby and champions of Lewiston's Intercollegiate Rodeo, all sponsored by the Golden Spur. (Nez Perce County Historical Society and Museum.)

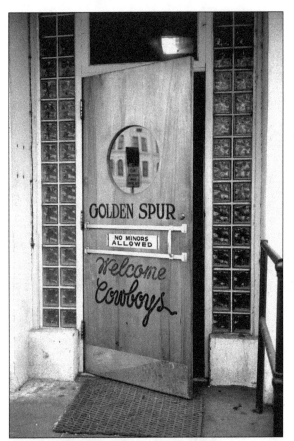

The Golden Spur was one of many places to get a drink in Lewiston in the 1950s. For many years, Tommy Thomas, the father of Rosalie Thomas (LHS class of 1960), managed it. The theme was "a little Western." Tommy always encouraged the sport of rodeo and local talent. This picture might spark memories of the old clubs like the Stables, Bojack's Broiler Pit, the Paradise Club, Chicken Roost, the Cellar, and more. (Nez Perce County Historical Society and Museum.)

This is a nighttime photograph of Ellwood Hirzel's music store at 720 Main Street in the early 1940s. It was by far the favorite store for kids in the 1950s, where they could go downstairs and find a large array of toys, crafts, and just about anything a kid wanted. On the main floor were the musical instruments and all the new popular rock 'n' roll records. (Nez Perce County Historical Society and Museum.)

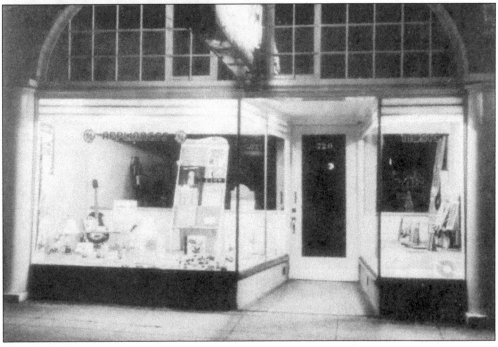

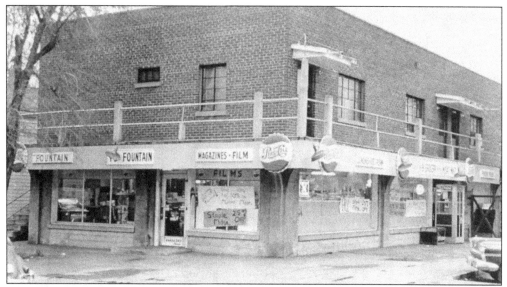

The YB was a very popular grocery store that had a food counter where people came for lunch and the kids came to have "graveyard" Cokes (a mix of all the cola flavors at the soda fountain). It was across the street behind St. Joseph's Hospital and St. Stanislaus School on Normal Hill. (Nez Perce County Historical Society and Museum.)

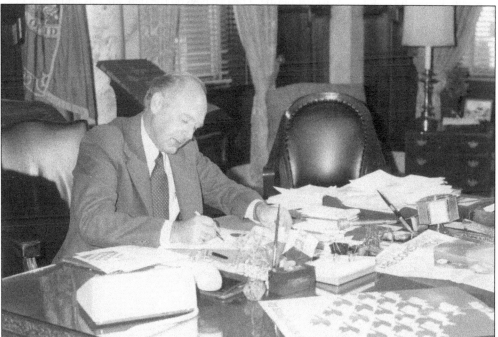

Cecil D. Andrus was a former logger who became Idaho's longest-serving governor, a US secretary of the interior, and a champion of the wilderness and of Idaho. In 1976, when he became the secretary of interior, he was considered the only possible candidate by Pres. Jimmy Carter. Andrus spearheaded conservation efforts and fished for steelhead and salmon and helped teach Carter how to cast with a fly rod and hunt elk and deer. Andrus died August 24, 2017. (Library of Congress.)

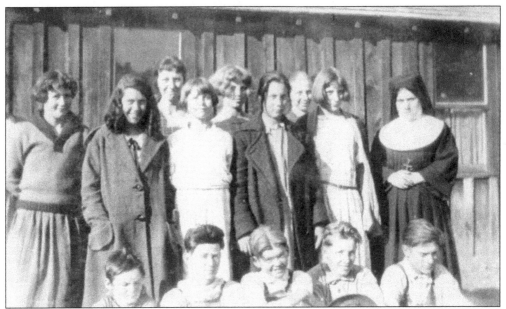

The Slickpoo Mission was located along Mission Creek just outside of Culdesac, Idaho. At one time, the St. Joseph's Mission grounds included a convent, children's home, and a church building. The nun on the far right is Sr. Mary Catherine. The two boys on the right are Ray and Frank Ebel, her brothers, who stayed there and helped with the farming. Fires twice destroyed the children's dorms—in 1916 and again in 1925. (Author's collection.)

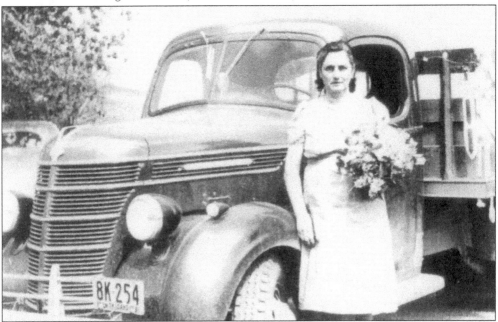

As a teenager, Louisa Aquino came to the United States from Italy. In 1925, her family bought a truck farm in North Lewiston. It was a time when gardens were planted as far as the eye could see. Louise Murphy was called the "Mayor of North Lewiston" for all of the work she did as a community leader to develop that area. She died in 1978. (Nez Perce County Historical Society and Museum.)

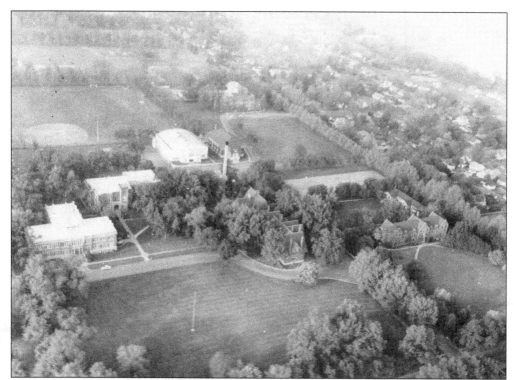

This is an aerial view of the Lewis Clark Normal School. The gym is prominent in the left middle of the photograph. (Nez Perce County Historical Society and Museum.)

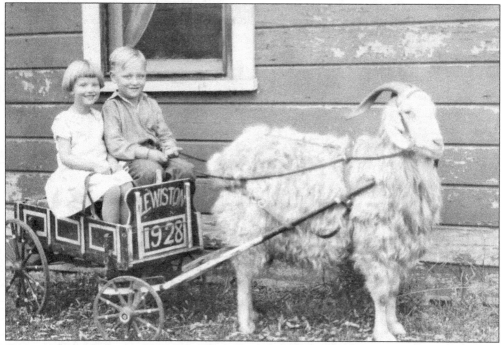

Goat carts came before go-karts. Patsy Ruth Henley and Lyle Norman Henley, eldest children of Lyle L. and Lillian Henley, enjoy a ride in this goat-powered wagon in 1930. (Bill Henley.)

In 1952, when these kids went to school, it would be some 20 years before kindergartens would become part of the local public school system. The teacher then was Mrs. Fred Walker, who held the kindergarten in her home at 328 Thirteenth Avenue. From left to right are (first row) Dick White, Larry Nicholson, Wally Hamilton, and Mike Malcom; (second row) Lee Anne Blake, Patsy Hayes, Julia Streiff, Linda Jackson, unidentified, Kathleen McCarthey, and Suzy Storey; (third row) unidentified, Hal Smith, Freddy Schmidt, Scott Whitcome, Gordon Matlock, and Luke Tyler. (Nez Perce County Historical Society and Museum.)

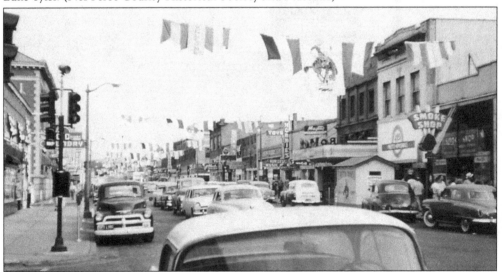

This 1954 photograph of downtown Lewiston was taken by Bill Gropp during the time of the Lewiston Roundup. The town displayed flags and other decorations. Ninety-one-year-old Bill was an operator at the Lewiston Dam. He left Washington Water Power Company to work for Bonneville Power in 1962. Another photograph of Bill's is on the cover of this book. (Bill Gropp.)

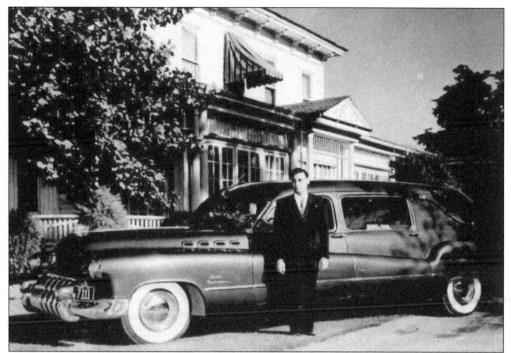

Kermit Malcom is shown standing in front of a new hearse at Malcom's Brower-Wann Funeral Home. The funeral home was established in a Victorian mansion on Main Street in Lewiston in 1924 by Loren B. Wann and Eugene Brower. Kermit and Betty Jean Wann were married in 1941 and later became part of the business. (Jason Harwick.)

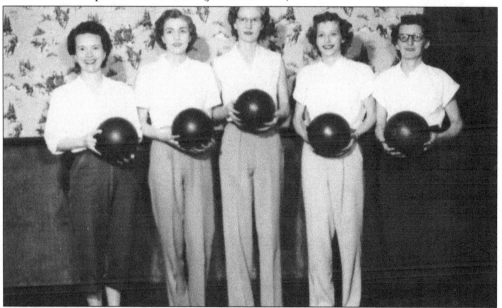

Bowling teams were popular during the 1940s and 1950s. Kegler's Club Bowling Alley was on Main Street near Willet's shop at Ninth and Main Streets. At the time, the wife of Bojack's Broiler Pit owner was on this team, along with Freda Jackson (far right). The other women are unidentified. (Author's collection.)

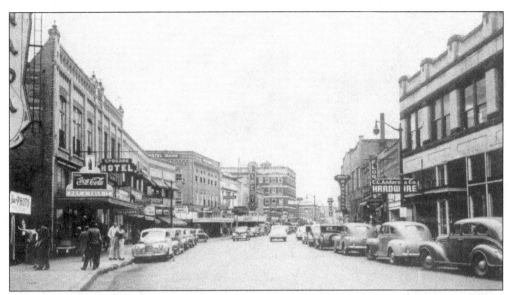

This image of downtown Lewiston shows the two-way traffic. Main Street became a one-way street on April 1, 1958. Many stores are still recognizable. On the left is the Brier Building, the tallest building downtown. The Liberty Theater sign is prominent, as are some of the other stores that used to be familiar sights downtown in the 1950s. (Nez Perce County Historical Society and Museum.)

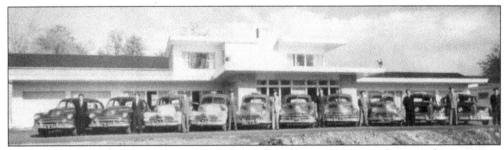

For over 50 years, the southwest corner of Eighteenth and Main Streets was home to the Sacajawea Motel. It was built in 1950 and underwent many renovations, including the addition of more motel units and a lounge. The Silver Streak Company parked its cabs in front of the motel in 1952 for this photograph. (Nez Perce County Historical Society and Museum.)

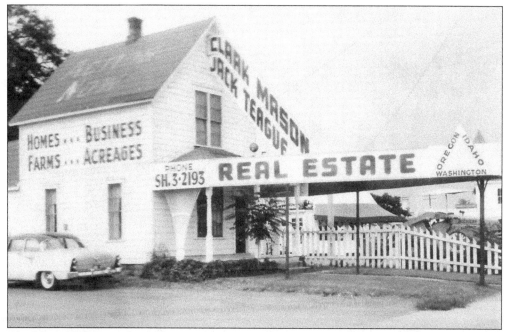

The Mason-Teague real estate house was located between Basil's Barrel and the International Harvester store near Eighteenth and Main Streets. Jack Teague and Clark Mason were partners specializing in ranches and farms around the late 1950s–early 1960s. The late Phil Schnabel lived in the house before it became a business. (Russ Mason and Susan Teague.)

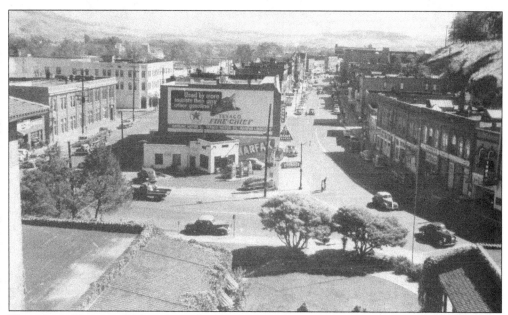

This view of Lewiston's Main Street looks east from the Lewis-Clark Hotel. It shows the Barton Service Station, which was later removed for a parking lot. This was the Main Street the kids cruised. (Nez Perce County Historical Society and Museum.)

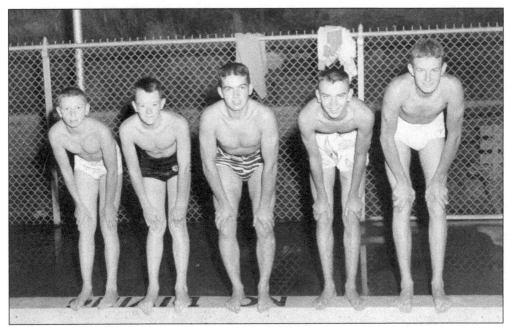

Some of the members of the Lewiston High School swim team look like they are ready to jump in and race in 1956. Bill Engle is second from the right, and the other team members are unidentified. (Bill Engle.)

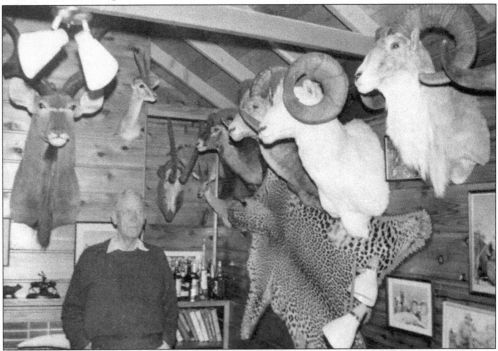

Jack O'Conner was an influential and award-winning journalist, hunter, and conservationist. He championed the wild sheep and wildlife his entire life. He wrote for *Outdoor Life* magazine, retiring in 1972. O'Conner wrote 16 books on big game and hunting. Jack's Hunting Heritage Education Center opened in 2006 at Hellsgate Park in Lewiston. (Dr. D.W. Heusinkveld estate.)

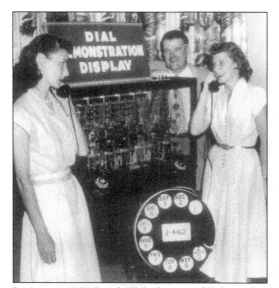 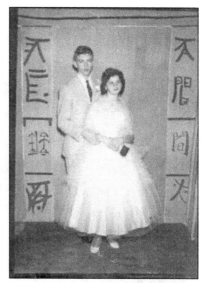

In August 1952, Pacific Telephone and Telegraph Company was preparing to switch from telephone operators who asked "number, please?" to a do-it-yourself dialing system. The equipment was placed in Mann's Music store at 527 Main Street, where the public was instructed how to use the new dial phones. In the image at left, Jeanne Miller and Maycel Putnam demonstrate the new system. In November of that year, Lewiston phone numbers had the prefix SHerwood (743) and Clarkston had PLaza (758). In the image at right, Frank Wagner, class of 1958, is shown in 1956 with his date, Janice Johnson, class of 1960. Notice Johnson's beautiful net formal and the dance card on her wrist. Wagner was a wonderful musician/guitar player who taught guitar to many kids and entertained at the LHS All-Class Picnic. He passed away in 2014. (Left, Nez Perce County Historical Society and Museum; right, Frank Wagner.)

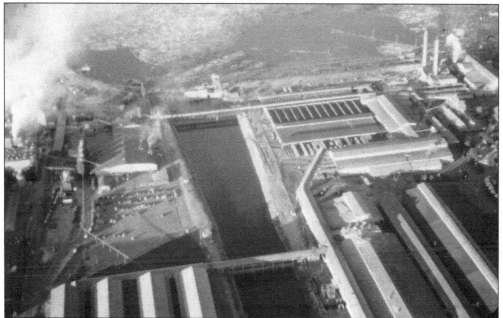

Here is another great picture sent in by Bill Gropp. This one is of Potlach Forest Incorporated. Gropp worked many jobs in his career. (Bill Gropp.)

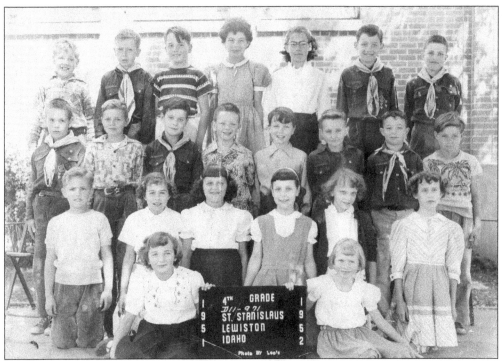

This picture shows fourth-grade students at St. Stanislaus School in 1952. They are, from left to right, (first row) Geraldine "Jeri" Jackson and JoAnne Troeh; (second row) Dick Vassar, Suzi Harootunian, Penny hall, Anne Marie Funke, Betty Rosholt, and Beverly Haughey; (third row) P.J. Walker, Gary Taylor, Maurice Hoffman, Bob Blewett, Jim Eisele, John D. Jackson, Garth Profitt, and Jim Bershaw; (fourth row) Tom Kaufmann, John Barnes, Billy Skelton, Sally Barnes, Kay Jo Ranta, Pete Gussenhoven, and Wally Von Bargen. (Author's collection.)

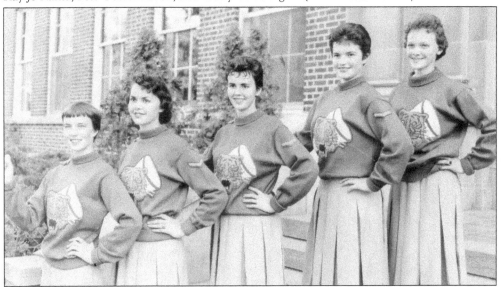

Newly elected cheerleaders pose on the front steps of Lewiston High School in 1958. They are, from left to right, Patsy Barker, Idora Lee Moore, Judith Geidl, Judy Olin and Enid Williams. (Lewiston High School Publications.)

Five

REMEMBERING THE GOOD TIMES

The 1950s were an exciting time to grow up in Lewiston. A lot of the guys had hot rods. It was such a thrill just to get into a car and cruise down Main Street, which meant starting by the Lewis-Clark Hotel and going all through town, waving at everyone. Cars would then turn the corner to Lew's Drive In, cruise through, and head back down Main Street again. (Main Street was a two-way street at the time.) (Asotin County Historical Society.)

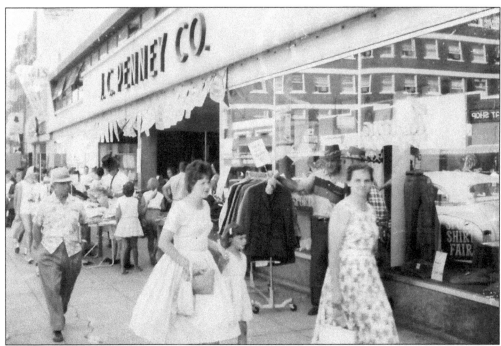

On Main Street in the 1950s, on almost any day of the week, people would walk around downtown, look in store windows, and visit. They especially liked the sidewalk sales. On Sundays, people would sit in their cars (as the stores were all closed) and just people watch. (Asotin County Historical Society.)

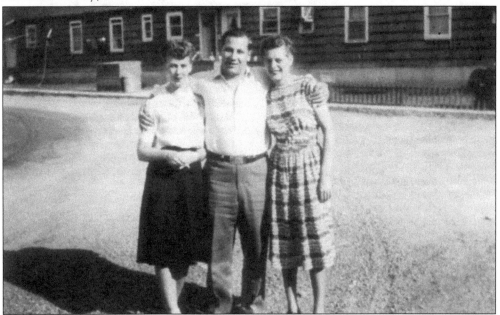

In the 1950s, the "housing units" were on Eleventh Avenue and Fourth Street and were called Veterans Village. Three residents pose in front of the former barracks where they found housing around 1940s. From left to right are Lucinda Hudson, Mike Booker, and Margaret Rose. (Esther Thorpe photograph, Nez Perce County Historical Society and Museum.)

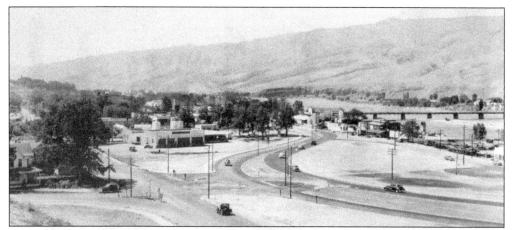

This is what the intersection at Twenty-First and Main Streets looked like in 1950. At this time, one can see the Eighteenth Street Bridge, shown in the background. It has been a part of Lewiston for 38 years before it was demolished in 1951. It was replaced by the new Clearwater Memorial Bridge. (Nez Perce County Historical Society and Museum.)

Prior to 1961, Twenty-First Street was the main road to the Lewiston Orchards. It was a narrow gravel road. When it became the most important north-south city arterial, that all that changed, as it was widened and the gravel surface was paved. In 1961, Smithy's Pancake House, shown at lower left, was the only restaurant on what is now called restaurant row. At the top of the photograph, the site of the barn owned by Bill McCann is the current location of Kmart, Wendy's, and, soon, Harbor Freight Tools—according to McCann. (Nez Perce County Historical Society and Museum.)

Shopping could be a hassle, and if in a hurry, one could go in the back doors of the businesses. In this c. 1970 image is a view of F Street, the street that runs parallel to Main Street in downtown Lewiston. Fairley's Bootery was a fashionable shoe store. F Street was entered from Fifth Street. (Bill Lintula.)

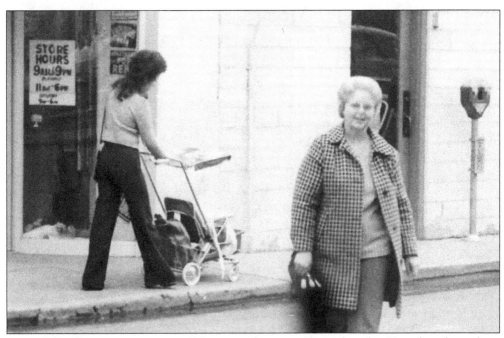

Bonnadale Johnson is seen crossing F Street on the way to the parking lot. Her job at the parking lot was to collect the money and give out the receipts for parking. The lot was just across the streets from the stores. The woman with the stroller is unidentified. (Bill Lintula.)

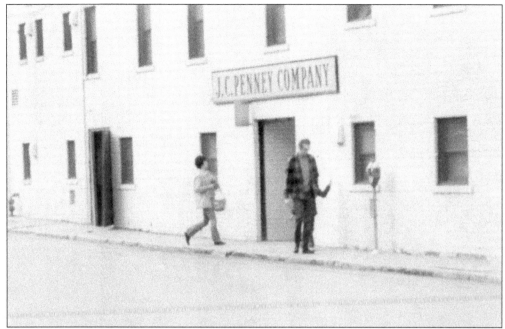

This is another photograph showing the back doors of the stores fronting on Main Street. It was so easy to just park in the lot and run in the back to pick up whatever. This c. 1970 photograph was taken outside J.C. Penney. Notice the old parking meters. (Bill Lintula.)

This c. 1970 photograph shows the parking lot on F Street behind the Main Street stores. In the distance is the Weisgerber Building, which was on Fifth Street. Sometimes, when LHS Bengal marchers were in parades, they would line up behind Main Street in this parking lot to get organized before the parade. (Bill Lintula.)

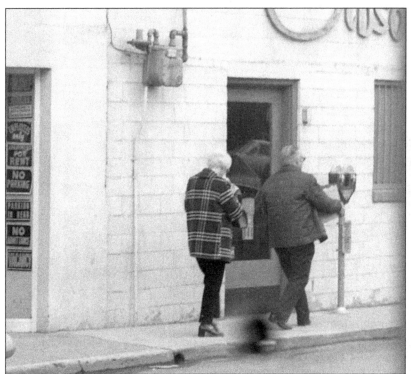

This is the back door to Gibson's Men's Wear store, on F Street behind Main Street in Lewiston, around 1970. There were also parking meters; the fee was 5¢ an hour, and meter maid fines were $1. (Bill Lintula.)

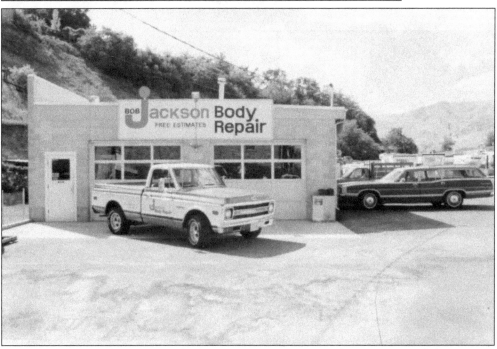

The first Jackson Body Repair was built at 856½ F Street. Tony Thompson owned the property and had the building erected around 1970. Later, Bob Jackson expanded his business by purchasing the building next door, which was the former Nash/Rambler dealership, built in 1961. John R. Jackson is now the owner of Jackson Body Repair. (John R. Jackson.)

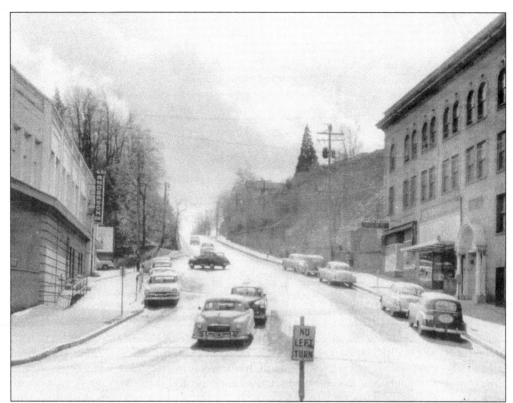

This 1956 photograph shows Fifth Street Hill between C.C. Anderson on the left and the Weisgerber Building on the right, whose entrance was unique. The door to the Lewiston Fur shop is on the upper right in the Weisgerber Building. (Nez Perce County Historical Society and Museum.)

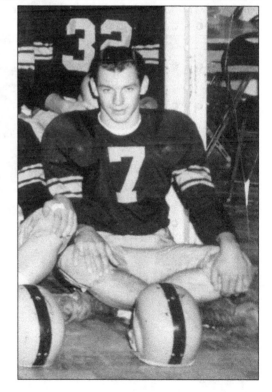

Kent Valley is pictured in his junior year on the Lewiston High School varsity football team in the 1956–1957 season. After graduation, Valley went on to play football with the University of Idaho Vandals, and served in Vietnam as a major with the US Marine Corps. (Bill Henley.)

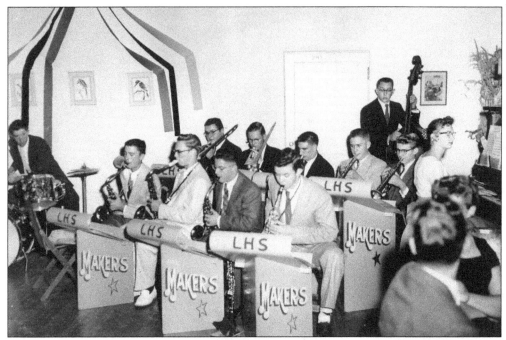

Members of the LHS Melody Makers band make music in the spring of 1957. Pictured are, from left to right, (first row) Ross Peterson, drums; Charlie Weaver, Gary Cox, Chet Peterson, and Brian Sanders, saxophones; (second row) Glen Manwaring and James McDowell, trombones; Dick Hastings, Bert Wilkins, and Ted Meckstroth, trumpets; (back row) Jim Wishard, string bass. At the piano is Sandra Flomer. The other woman and man at the piano are unidentified. (Bert Wilkins.)

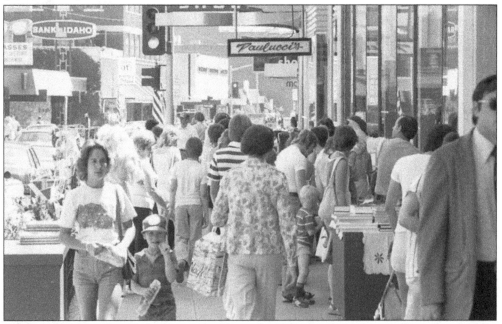

Shoppers for "Crazy Daze," which started in the in the 1950s, are shown here walking the sidewalks for the bargains. Many businesses' signs are shown here in the 1970s. (Bill Lintula.)

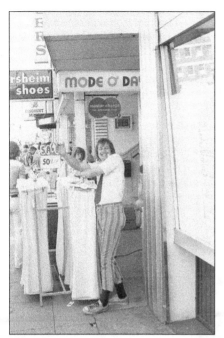 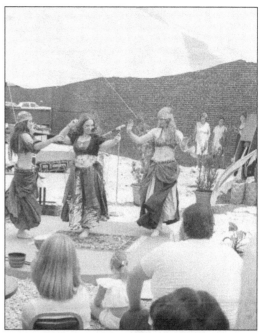

Crazy Daze went on for over 30 years as downtown merchants promoted their businesses with an annual sidewalk sale. With drastically reduced prices, the event was held one weekend during the month of July. Customers and staff would appear in makeshift costumes to add to the craziness. More Crazy Daze fun is shown at right as dancers perform at Brackenbury Square in this c. 1970 photograph. The crowds enjoyed not only the sales and the fun but also the entertainment. (Both, Bill Lintula.)

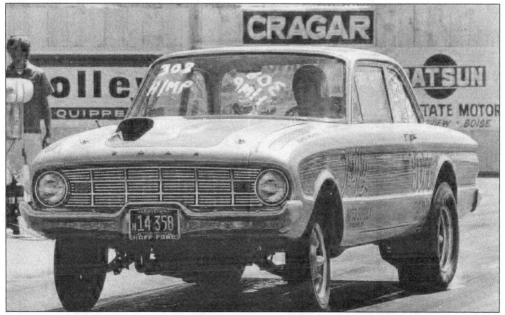

In the 1950s, hot rods were everywhere. The guys loved them, and so did the gals. This picture was taken at Firebird Raceway in Boise, Idaho. Donnie Jackson worked at the local Ford dealerships for years, retiring from Tony Copeland Ford. The car shown here is a Ford Falcon. (Russ Mason.)

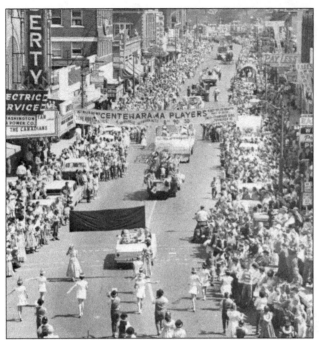

The centennial parade was a huge celebration. Thousands of people lined Lewiston's Main Street on May 14, 1961. The royalty was Cheri Berg, Linda Berg, and Judy Pederson. Cheri was crowned Queen of the Lewiston Centennial. Many local people got in the spirit of things and wore costumes of the period. Children dressed up too, and many rode on the floats. (Nez Perce County Historical Society and Museum.)

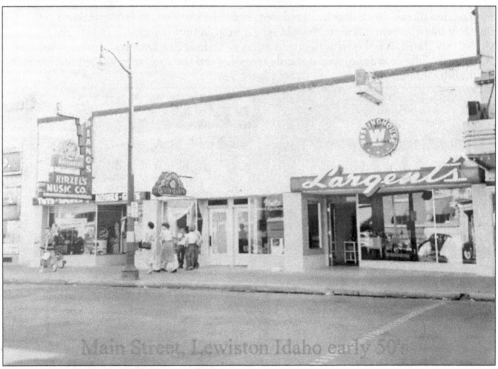

Largent's appliance store has been a fixture in downtown Lewiston for many years. In the past year, the store has uncovered the old facade—and it is beautiful with its curved windows. This shows the storefront at 718 Main Street in the 1950s. Ralph Largent moved there in 1940. Hirzels was right next door, and many kids spent time there, finding the perfect toy, craft, record, or instrument. (Largent's.)

The Vogue Shop was a special little boutique and hat shop. It was the perfect place to browse and find the ideal treasure. There was another hat shop in Lewiston, and the hats were displayed in little stands all up and down the wall. People used a big hook to get the hats down to try them on. (Nez Perce County Historical Society and Museum.)

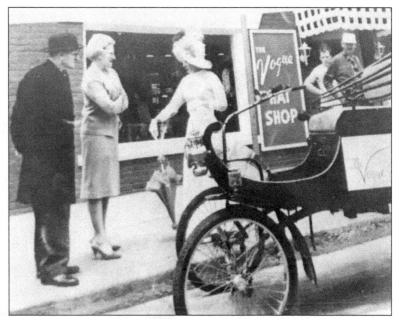

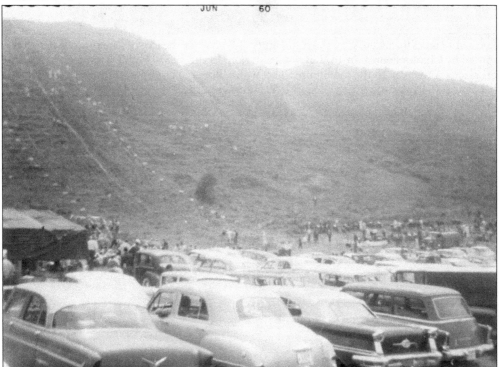

Motorcycle hill climbs were very popular in the 1940s, 1950s, and 1960s. Racers used Mark Means Hill and others for climbs in the area. Local resident Art Schwab remembers, "I did go to the climbs and took pictures. I rode small Japanese bikes in the hills and on scrambles tracks, and cross country." The Lewiston Hill climb was famous in bike circles. Events attracted a lot of spectators. People with motorcycles loved to race up the Lewiston Spiral Highway as well. (Dana Rae McKay Williams and Dave Welch estate.)

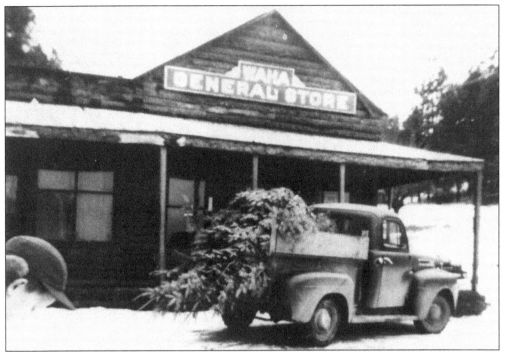

Located 19 miles from Lewiston, the community of Waha is at the foot of Craig's Mountain. It was started by Charles Founce in 1892 as a stage station. In the 1950s, Waha was a popular cooling off place on the way to the mountains. The Waha Store's famous natural ice cave stored cold beer and soft drinks; the store closed in 1958 and burned in 1983. (Nez Perce County Historical Society and Museum.)

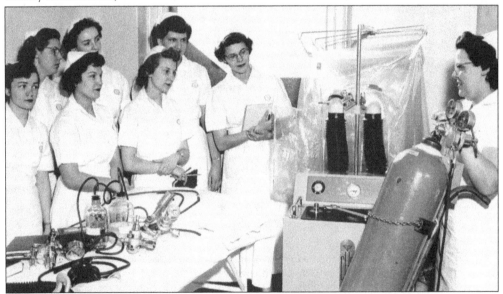

Here are the women who began nursing school in September 1951. The students on the left are, from left to right, (first row) Mary Gonder, Patricia Church, Marlene Haag, and Connie Akins; (second row) Betty Lorenz, Janet Flomer, and Lorraine Hampton Hansen. In February 1952, they had their capping ceremony. (Nez Perce County Historical Society and Museum.)

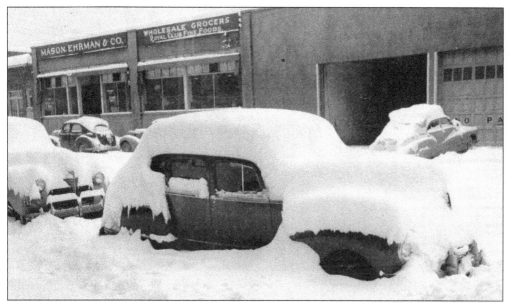

On January 15, 1950, it snowed 8.7 inches, setting a record for a one-day snowfall ever in Lewiston. This photograph was taken at First and Main Streets. It was rare to get so much snow in Lewiston at all. The kids were thrilled to be able to go out, make snowballs, and use their Christmas sleds. (Linda Munson Covey.)

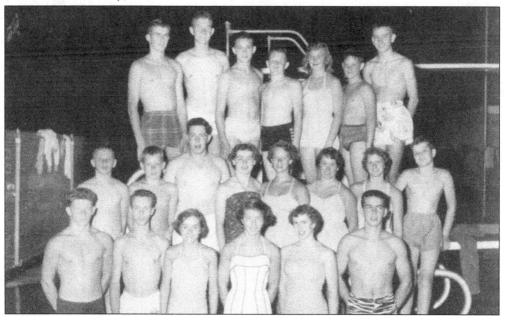

This was the Lewiston Swim Team in 1952. At the time, the team represented Lewiston in the swim meet in Nampa, Idaho. From left to right are (first row) coach John Gillis, Jim ?, Paula Harootunian, Donna Gale, Anne Marie Berry, and Jim Peltier; (second row) Frans Gustafson, Cody Abbott, Ed Schmith, Coleen Engman, ? Turner, Marilyn Mulroney, Alice Sweeney, and Doug Peterson; (third row) team captain Kay Berry, Roger Hansen, Barry Elsensohn, Bob Moore, Leah ?, Bob Harris, and Bill Engle. Not shown are Dave Huff, Dave Edison, Pat Lotz, Marilyn McNamara, Mary Jo Mace, and Jack ? (Nez Perce County Historical Society and Museum.)

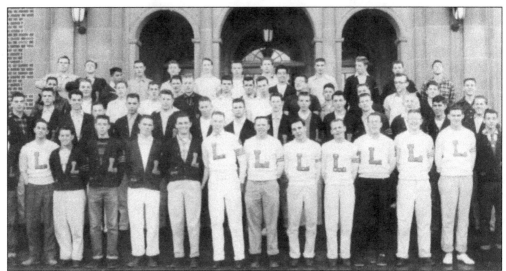

The Lewiston "L" club was established in 1923. From left to right are (first row) unidentified, Sam Canner, Bob Harris, Jim Bowen, Lonnie Ayers, Barry Elsensohn, Rikki Nelson, Frans Gustafson, Larry Hayden, Bob Pierce, Don Grove, Don Evans, Vernon Hans, and Bob Huddleston; (second row) John Bennett, Ron McMurray, Jim Coffland, Joe Chapman, unidentified, Stan Harwick, Chuck Norton, Cody Abbott, Gerry Dietz, Ron Karlberg, Bud Alford, Terry White, Cliff Trout, Tom Gilbertz, Dick Wyatt, and Danny Seaton; (third row) Bob Tuell, Glen Manwaring, Barry Edwards, Waymon Gay, Bob Emerson, Bob Edmonson, Paul Bailey, Joe Ketchum, Jerry Mahoney, Gary Larson, Chug Frank, Dog Peterson, Rick Bentley, Mike Hagen, Larry Ferguson, Larry Clark, and Dick McDonald; (fourth row) Lee Norden, John Mahoney, Butch Taylor, Larry Edwards, Ron Grant, Dave Nichols, Andy Klemm, Ron Shoemaker, Dick Hastings, Larry Dickinson, Scott McKean, and Mac Blakely. (Lewiston High School Publications.)

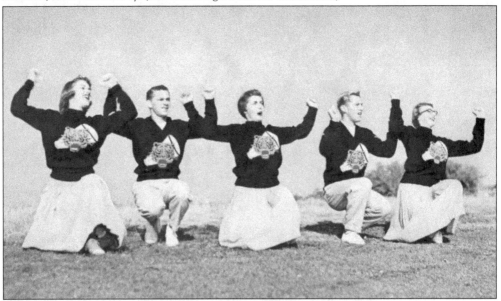

In 1956, the five cheerleaders do a cheer out in the sunshine. From left to right are Ann Marie Berry, Bob Harris, Cara McCann, Dan Seaton, and Barbara Brandon. The cheerleaders were known for their spirit and enthusiasm. (Lewiston High School Publications.)

The 1956 flag twirlers marched with the Lewiston High School Band in parades and during demonstrations. Pictured are, from left to right, Mary Jo Mace, Betty Miller, and Jan White. (Lewiston High School Publications.)

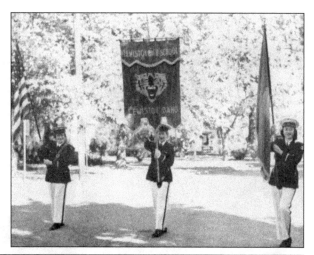

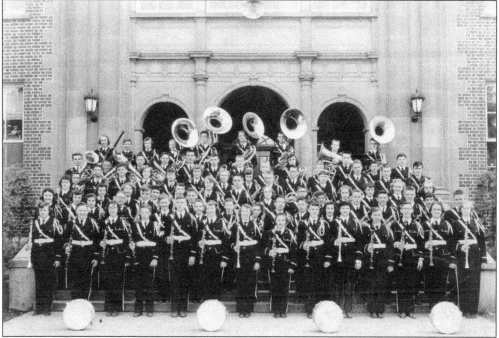

The Lewiston High School Band is shown in this photograph. The students shown here were from LHS classes 1957, 1958, 1959, and 1960. From right to left are (first row) Isabel Woods, Minda McLaughlin, Dean Pontius, Jerice Gilson, Sandy Dyer, Sharon Chase, Pat Christiansen, unidentified, Barbara Whipple, Frank Wagner, Ron Hibblen, unidentified, Dave Mullally, and unidentified; (second row) Bert Wilkins, Judy Meehan, Ed Barney, Delmar Skaret, Wayne Thiessen, Karen Kessler, unidentified, Marvin Peterson, Dean Meyer, Monte VanSise, two unidentified persons, Ed Schwartz, two unidentified persons, Gloria Birkland, and unidentified; (third row) Mickey Pierce, Linda Berg, Jane Ruckman, two unidentified persons, Dorothy Sergeant, Dick LeFrancis, Carol Kovanen, four unidentified persons, and Darlene Berry; (fourth row) unidentified, Eric Rauch, Suzette Frost, Doug Mahurin, Neil Modie, Patty Ruark, unidentified, Nola Elben, three unidentified persons, Charlie Weaver, and unidentified; (fifth row) unidentified, Jack VanSise, Gary Overman, Richard Seitz, Charlotte Mayer, two unidentified persons, Bob Ruark, unidentified, and Steve Schwab. (Bert Wilkins.)

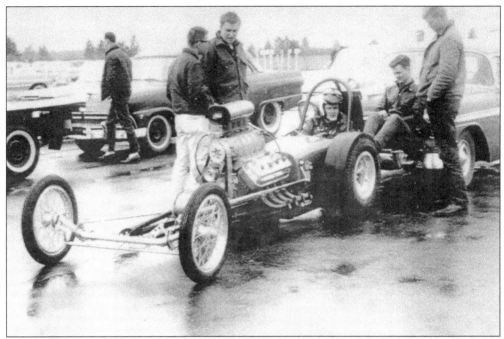

This picture is of the drag races in Deer Park. Many valley people hauled their cars and dragsters 115 miles north to race there. Identified are Doug Dahlgren (second from the left), Russ Mason (in dragster), Terry Frost (sitting on the edge), and Dave Favor. (Russ Mason.)

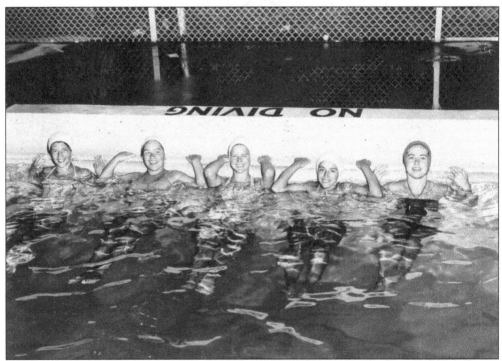

These unidentified gals are enjoying the water at Burt Lipps Pool in 1956; they look like they are getting ready to be a swim team. The Lewiston Pool was always fun and crowded. (Bill Engle.)

Judith Geidl cheers during the 1958 LHS bonfire. Students had collected the tires and competed to see if Lewiston would have a larger bonfire than its rival, Clarkston High School. Because of the black smoke and complaints, 1960 was the last year of the bonfires. (Judith Geidl.)

Seven Lewiston High School girls from the class of 1959 pose after playing tennis during physical education in 1958. From left to right (first row) Enid Williams and Mickey Pierce; (second row) Cheri Crowe, Linda Wolf, Linda Engle, Judy Olin, and Diane Rowland. (Lewiston High School Publications.)

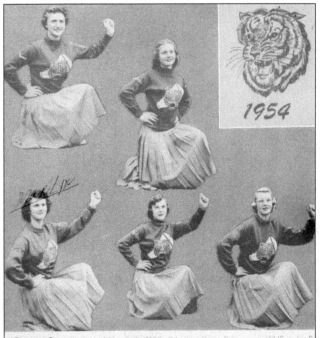

Cheerleaders for the 1954 year sure generated pep—"Let's go! Yea bo!" was their cry. From left to right are (bottom row) Marilyn Crane, Alyce Sweeny, and Pat Brannon; (top row) Arlene Martin and Arlene Maynard. The girls led the student-body cheering sections at the home games and many out-of-town contests. (Lewiston High School Publications)

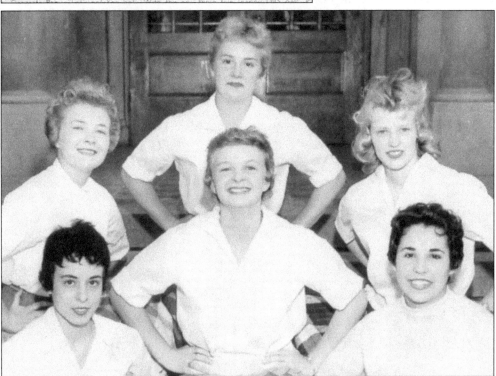

On April 24, 1959, these LHS cheerleaders were elected for the new year. From left to right are (first row) Jo Ann Smith, Sandy Banks, and Sharon Thomas; (second row) Diane Berkley, Carol Lawrence, and Jane Modie. Berkley, Banks, and Thomas were members of the class of 1960, and the other girls were in the class of 1961. (Ron Karlberg.)

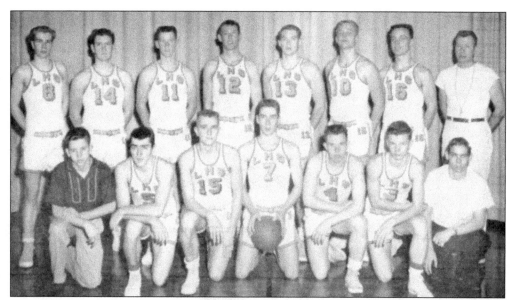

The Bengals broke even in basketball in 1957. From left to right are (first row) unidentified, Bill Mayer, Mick Woodland, Chug Frank, Jerry Mahoney, Paul Hines, and Scott McKean; (second row) Gary Coffland, Ron McMurray, John Hansen, Duane Ailor, John Cornell, Ron Karlberg, Andy Klemm, and coach Wes Latham. (Lewiston High School Publications.)

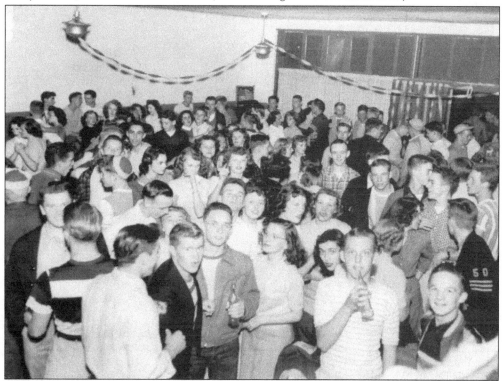

Seen in a 1949 photograph, the YAC (Youth Activities Center), located at 136 Ninth Street, was a hangout for teenagers. It was a great place to dance, play table tennis, and have fun after football games. (Nez Perce County Historical Society and Museum.)

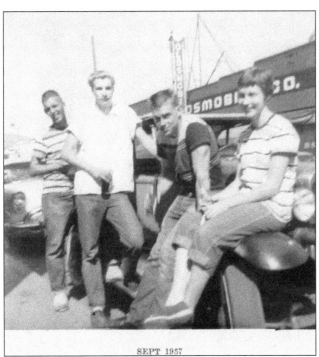

Shown around and on cars while waiting for the YAC to open in 1958 are, from left to right, Vernon Storey, Phil Olson, Stan Baker, and Pat Simmons. (Judith Geidl.)

SEPT 1957

The YAC was an important youth center from 1944 to 1970. YAC dances included the Sadie Hawkins Day in November and the Yule Dance in December. Girls wore Jantzen sweaters, and the guys wore pink shirts, slim belts, and white bucks. Sometimes, the girls danced with the girls, as they knew the dances and many guys were shy. (Nez Perce County Historical Society and Museum.)

The third supervisor for the YAC was Roy Pearson, who also drove a delivery truck for Holsum bakery that required him to begin his deliveries in the very early morning. This made the hours of operations at the YAC change, to 7:00 a.m.–12:00 p.m. on Fridays and Saturdays, as well as one night during the week, usually from 7:00 to 9:00. Pearson was a great guy and loved by all. (Nez Perce County Historical Society and Museum.)

Lewiston High School was a beautiful building in the 1956. Its west side had just been renovated to make room for more students. Lewiston High School is the only traditional high school in the Lewiston School District. The school colors of LHS are purple and gold, and the mascot is the Bengal. (Nez Perce County Historical Society and Museum.)

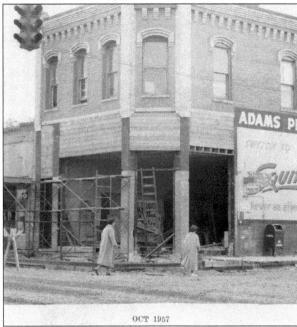

OCT 1957

In 1955, the Bantam Hut was a rival to Lewiston's dance place, the YAC. The Hut was above the Adams Pharmacy. There was a staircase between Adams and Tom Smith's Nut Shoppe leading upstairs. It was a fun place to dance—especially with an LHS rival—and get a Coke and maybe popcorn. There were also Ping-Pong tables and a jukebox, bought by the students of Clarkston High School. (Asotin County Historical Society.)

The 410 Drive-In is an iconic institution that is still in business today. The 410 Drive-In in Clarkston was along the route that the teens took as they "cruised Lew's" and "dragged the gut" (cruised Main Street). It was always a must to stop and have the 410's famous curly fries. (Brianna Jackson.)

Posing in front of Lewiston High School are, from left to right, Sharon Chase, Louise Merrell, Helen Anderson, Roy Hovey, Judith Geidl, and Dave Gusseck. (Judith Geidl.)

In 1959, the Lewiston High School Council officers were elected. From left to right are Linwood Laughey (president), Bridget Wicklund (secretary), and Jim Bounds (vice president). They all graduated in 1960. (Ron Karlberg.)

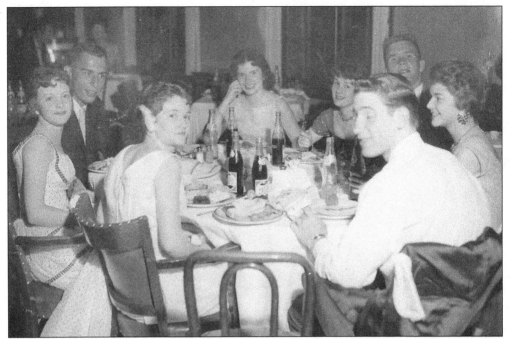

This picture was taken at the Lewis-Clark Hotel, where the LHS class of 1957 had their graduation party. In front in white is Bonnie Huddleston, and to her left are Enid Williams, Stan Harwick, Penny Banks, Gerry Dietz, Joan Goodall, and Tim Linnenkamp. All the girls were in the class of 1959, and the guys were in the class of 1957. Not pictured is Waymon Gay. (Penny Banks.)

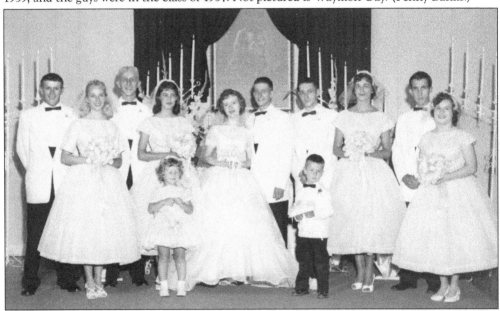

This is a photograph of Doug Munson and Jolonda Schmdit's wedding party. The adults, from left to right, are Leroy Johnson, Caroline Ward, Tom Gilbertz, Linda Munson, Jolonda, Doug, Bob Huddleston, Joanne Janni, Gary Storey, and Phyllis Adams; the two kids are Lonna's brother's children, Cindy and Danny Schmidt. All the guys were in Doug's class of 1956, and the girls were in Lonna's class of 1957. (Doug Munson and Linda [Munson] Covey.)

On her way to school, Linda Munson enjoys a maple bar at Claude and Betty Trowbridge's neighborhood store on Eighth Avenue in 1953. The store was in Lewiston between Third and Fourth Streets, near the college; it was one of a number of mom-and-pop neighborhood stores at the time. (Linda [Munson] Covey.)

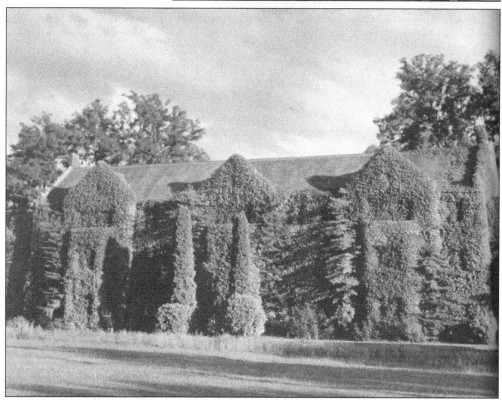

The state closed North Idaho College of Education in 1951, and it did not reopen until 1955. Beautiful green ivy grew on Spaulding Hall during the time the college was closed. Sometimes, the ivy would find its way in and wrap itself around the typewriters. Spaulding Hall was built in 1924 as a dormitory. (Nez Perce County Historical Society and Museum.)

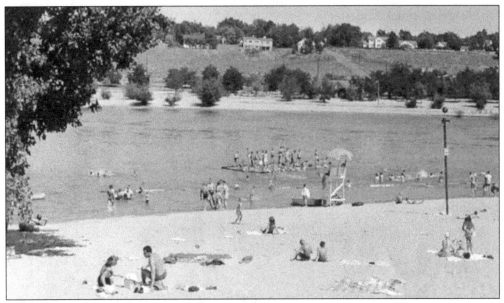

The view from Clarkston Beachview Beach shows Lewiston, Idaho, across the river. The hilly road is Eleventh Avenue, which went down to the Lewiston Beach. The Clarkston beach was the best beach and a hangout for teens and families. The water was shallow, and many people told how they swam across the Snake River to the other side. (Nez Perce County Historical Society and Museum.)

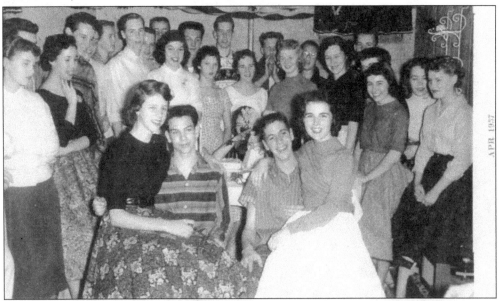

In 1957, some members of the class of 1960 enjoy a party in Judy Currin's basement in North Lewiston. From left to right are (front row) Glenna Gale sitting on Scott Tipton's lap and Cliff Paffile with Judy Currin sitting on his lap; (second row) Peggy Knutson, Pink McFarland, Sharon Thomas, John Rasmussen, Dick Baker, Kurt Smith, Michaelann Wood, Joyce Dale, Jeri Jackson, Judy Chapin (almost hidden by flowers), Sandy Banks, Jerice Minnette, Janice LaBelle, Suzi Harootunian, Rosalie Thomas, and Dawna Nisson; (third row) Mike McHargue, unidentified, Russ Northrup, Jim Clubby, Al Isaac, Ed Paffile, Bill Woodland, and John Jackson. (Author's collection.)

Sam and Shirley (Smith) Canner pose in February 1959. Sam was in the LHS class of 1956, and Shirley was in the class of 1960. People married younger in those days, and the Canners have celebrated over 58 years together. Their family now has five generations of "Sam Canners." Others married by going to Coeur d 'Alene, Idaho, to the Hitching Post. (Sam and Shirley [Smith] Canner.)

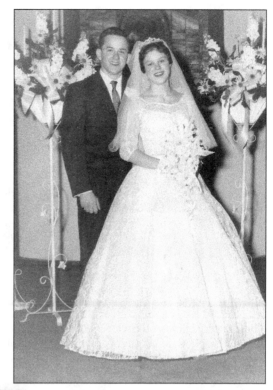

Tom and Jennette Hoffman are at the Sweethearts Paradise dance at Clarkston High School (CHS) in 1960. She was from Clarkston High School, class of 1961. They were married before she graduated from high school and have been married 56 years. Tom was in the class of 1958 at Lewiston High School. Although they were from rival schools, romance always won in the end. (Tom and Jennette Hoffman.)

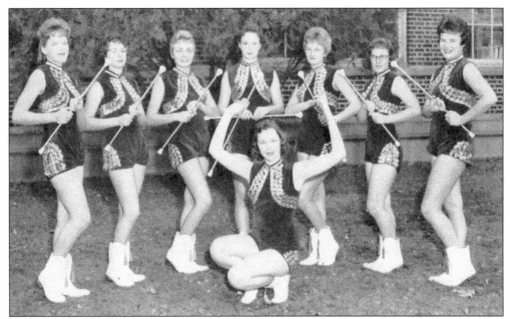

These talented Lewiston High School majorettes performed at various game and parades during the 1950s. This photograph was taken in 1960. Standing from left to right are Dorothy Fredrick, Judy Masters, Sharon York, Sandra Steinman, Sharon Nichols, Barbara Jackson, and Marcena Rubright; senior Jerice Minnette (kneeling) was the leader. (Lewiston High School Publications.)

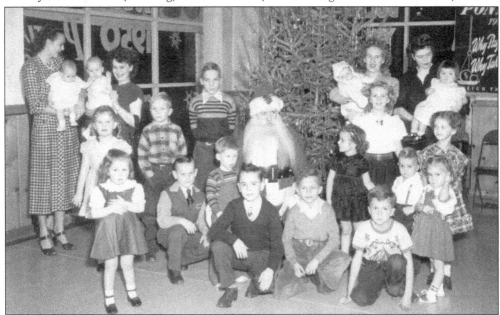

E.V. Lorenz, owner of Lorenz Pontiac at Fourth and D Streets, held Christmas parties for his employees and their families from the 1940s through early to mid-1950. Ed Otten stands toward the back directly to Santa's right, and Sid Otten is to his right; to Sid's right is Gwen Hyke. (E.V. was Hyke's grandfather.) Bill Otten kneels in the center of the first row, and brother Jim Otten is kneeling to his left. The two Gill sisters are on the right side of the picture, standing in front of the two ladies holding little ones in 1950. (Bill Otten.)

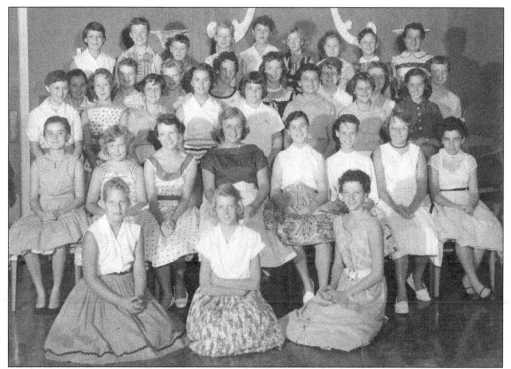

These are students at the charm school sponsored by Brown's Tog Shoppe in the 1950s. From left to right are (front row) Sylvia Brotherton, Susan Miles, and Diana Flinn; (second row) unidentified, Judi Weldon, five unidentified, and Carolyn Ellis; (third row) all unidentified; (fourth row) eight unidentified and Elaine Dicus. (Sylvia Brotherton.)

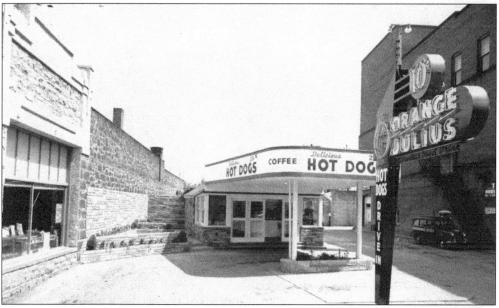

The Orange Julius drive-in, located at 847 Main Street in Lewiston, is shown here around 1952. Look at the prices: a hot dog for a quarter and a drink for a dime. Today, US Bank is located at this site. (Nez Perce County Historical Society and Museum.)

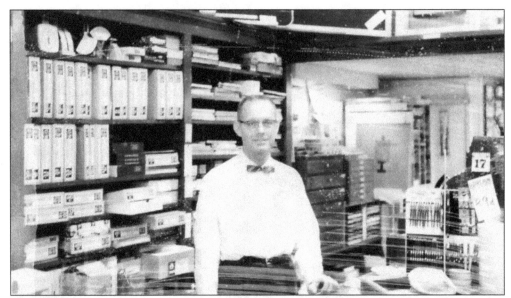

Frank Miles, the owner of Klings, is shown in his store. His daughter Karen, LHS class of 1960, remembers the fire: It started in the smoke shop next door. Her parents were living in an apartment above the store and escaped onto the adjacent rooftops. They lost everything, including their business and home, and were pretty devastated. Rubble was taken to the dump, where "pickers" retrieved one old family photograph album, which Karen still has, and her dad's wallet. The store was rebuilt but is now closed. The Karmelkorn recipe and equipment was purchased by Wasem's in Clarkston, where one can still buy some today. (Nez Perce County Historical Society and Museum.)

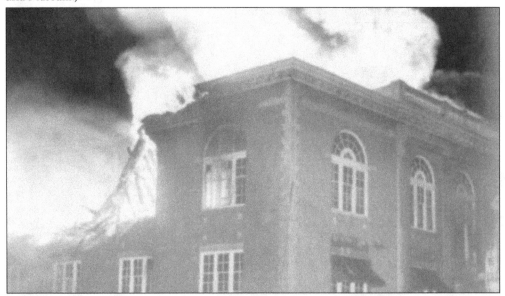

The Elks Lodge in downtown Lewiston was established in 1904, but a fire gutted the beautiful old building. The lodge was later rebuilt near Country Club Drive and has a beautiful 180-degree view of Snake River. Several years ago, the land under the new building started shifting, and there were many engineers and trucks out there for a long time making repairs. (Nez Perce County Historical Society and Museum.)

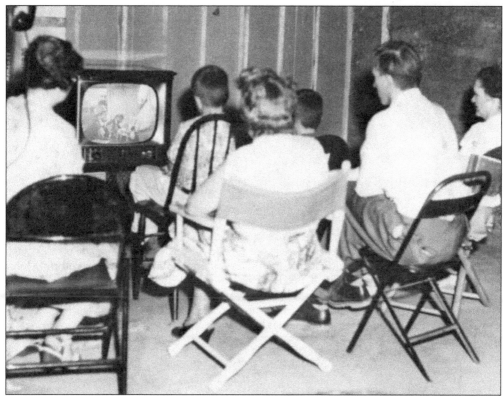

Television comes to Lewiston. One was very lucky if a neighbor had a television set in the summer of 1953, as not everyone could afford one. The new coaxial cable came from Spokane. It took a long time to get television in those days. Some people bought antennas and watched local TV station KLEW-TV. (Nez Perce County Historical Society and Museum.)

This photograph is from the Freshman Ball for the LHS class of 1960. The theme was "Singing in the Rain." Michaelann Woods is show with her date, John Jackson, in 1957. Both students were from the class of 1960. (Author's collection.)

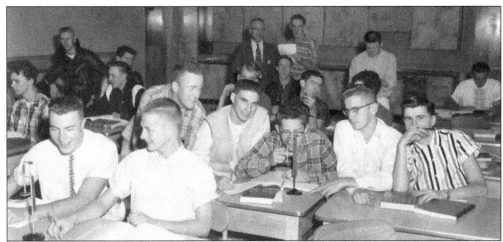

Pictured here are students from the LHS class of 1957 in S.S. Scheibe's 11th-grade physics class. Pictured are, from left to right, (first row) John Cornell and Clinton Trout; (second row) John Stiles, Dick Hastings, Mick Woodland, Bob Boie, and Kurt Sundelin; (left rear) Rod Mayer, Richard Parr, Russ Mason, and Mike Frost; (third row) Bill Henley (half hidden), Larry Dickinson, Bill Hart, and unidentified; (far right) Rod Mayer and Jerome Finnell; (standing) teacher Scheibe, David Riddle, and Clyde Vassar. (Bill Henley.)

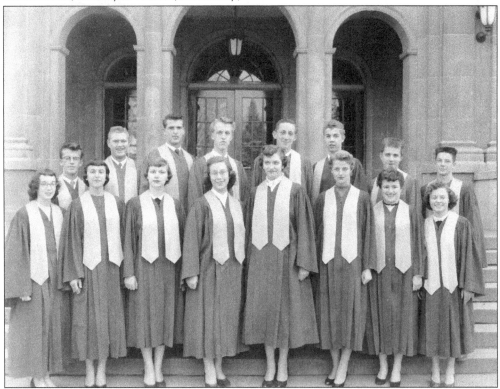

The LHS 1957 Mixed Ensemble is shown here on the steps of LHS. From left to right are (first row) Darlene Knight, Jan Smith, Kris Madison, Joan Tannahill, Madlin Falwell, Margaret Sue Bauder, Vivian Cole, and Phyllis Adams; (second row) Bill Kemp, Ken Knautz, Ron McMurray, Bill Henley, David Riddle, Scott McKean, unidentified, and Ron Barton. (Bill Henley.)

The Medical Center Foundation of St. Joseph Hospital, Inc. was formed in 1975. This photograph was taken before the renovations. The photograph was used for raising funds to do renovations. From the tiny hospital of seven beds on Snake River Avenue, St. Joseph Hospital has come a long way, with expanded large emergency department, new lab, gift shop, and six operating rooms, plus the scope of the radiology department increased. (Dr. D.W. Heusinkveld estate.)

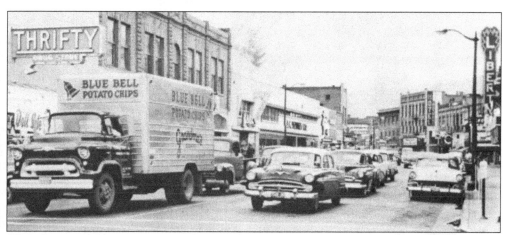

This photograph shows Main Street when it changed to one-way traffic in 1957. Lots of signs speak of old businesses that were popular in the 1950s and are no longer there or in the same place. Thrifty Drugs and J.C. Penney have left, and the Liberty Movie Theatre has closed. The view in this picture looks westward. (Nez Perce County Historical Society and Museum.)

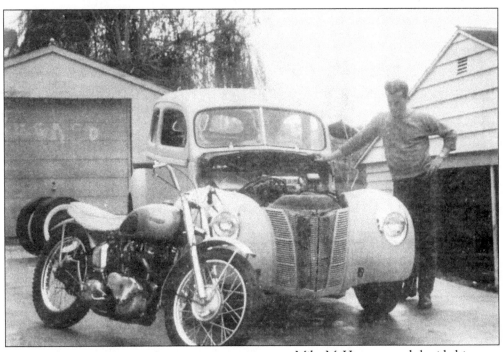

Mike McHargue stands beside his hot rod and his motorcycle in the Lewiston Orchards. Guys spent a lot of time and money trying to get the fastest car in town. They were working on their hot rods all the time, and when they were not doing that, they were either racing up the Lewiston Spiral Highway or going to the Deer Park Drags. (Mike McHargue.)

Senior John D. Jackson, and his date, Ginger Lang, attended the 1959 Senior Ball at Lewiston High School. The theme was "Shangri-La." A celestial air was created by the harp, and an angel hovered behind the background while couples sat on the swing. It was a time when men wore suits and the gals had corsages and wore beautiful formals with layers of netting. (Author's collection.)

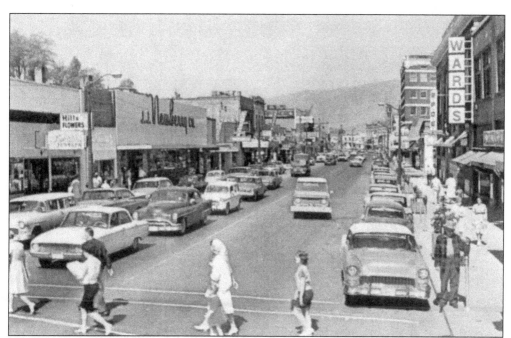

A lot has changed in downtown Lewiston at New Sixth and Main Streets since this photograph was taken in 1960. Some businesses pictured that are no longer there are Hill's Flowers, J.J. Newberry Company, Montgomery Ward, and more. The Elks Lodge was destroyed by fire in 1969. (Nez Perce County Historical Society and Museum.)

The old Dairy Queen was opened in 1952 by Guy Mclaughlin. He sold the building to Lew Flora, who, after some remodeling, opened Lew's Drive In in April 1955. It was located at 115 Lincoln Street. Lew's quickly became a popular destination for the teen set in the 1950s and 1960s. The slogan of the day was "Let's cruise Lew's." Other popular places to eat were Tip Top, 410 Drive-in, Chicken Roost, 24 Flavors ice cream, and more. The list was long. (Ron Karlberg.)

The Tip Top Drive-In was in North Lewiston right on the highway on the left coming into town from the Lewiston Hill. It was another favorite eating spot. The building is still there, but the drive-in is closed now. According to Bill Engle, there was an earlier Lew's that had to move when the old Eighteenth Street bridge was taken out back in the 1950s. (Brianna Jackson.)

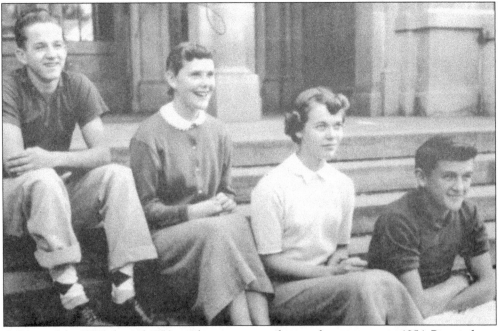

Officers of the LHS class of 1956 are shown starting their sophomore year in 1954. Pictured are, from left to right, Sam Canner (vice president), Joan Baldeck (secretary), Pat Nichols (treasurer), and LeRoy Johnson (president). (Lewiston High School Publications.)

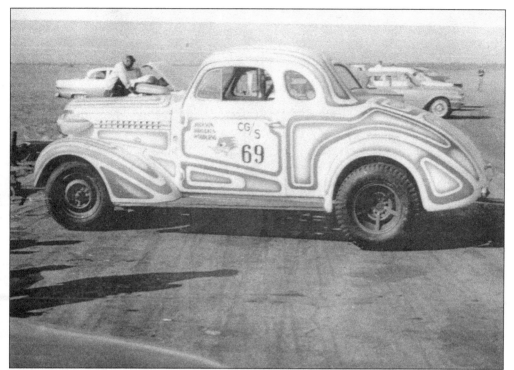

John D. Jackson was a well-known sight around town with his 1938 Chevy. He loved racing cars, whether it was down Main Street or out to the dam or trying to break the record for how fast he could race up the Lewiston Hill. Jackson raced at Deer Park and won 13 trophies before he was tragically killed by a car at Lewiston Dodge Garage on July 20, 1962. (Author's collection.)

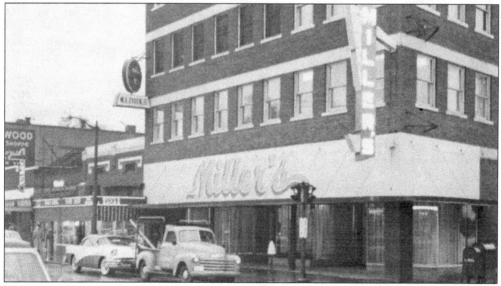

Miller's department store was on Main Street in the Brier Building. It had its grand opening in 1957. The Brier Building was the tallest building in Lewiston and one of the three buildings in town that had an elevator. Many offices were in the upper floors, and at one time, it had a mezzanine where one could go for lunch. (Nez Perce County Historical Society and Museum.)

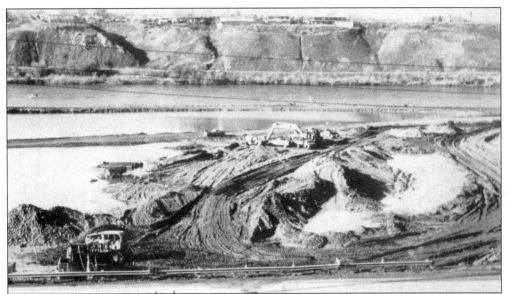

Lewiston and Clarkston's dike project on the Snake River is shown on December 10, 1973. This is the construction of the Southway boat basin at Southway and Snake River Avenues. This what it looked like as everything changed and Lewiston became Idaho's only seaport. When the project was finished in 1975, the slack water arrived and covered all the local beaches. It was the end of an era. (Nez Perce County Historical Society and Museum.)

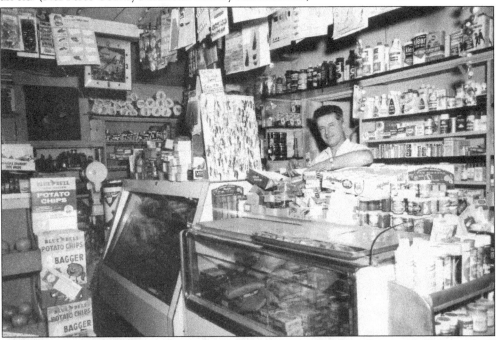

This is the inside of Dick's grocery. It was the only store open on Sundays and holidays, which was unheard of back in the 1950s. It was said if Dick did not have it, one did not need it. The first Dick's grocery was originally on the corner of Seventeenth Street and Eleventh Avenue. The old store was torn down, and the new store now faces Eleventh Avenue. (Nez Perce County Historical Society and Museum.)

Lewiston High School students hold a traditional bonfire before the annual game with Clarkston High School in 1957. Clarkston held its own bonfire, and the competition over which school had the biggest blaze nearly overshadowed the rivalry game. Some of the people identified in the crowd are Lorene White, Gerald Harwig, Scott McKean, Johnny Rasmussen, David Riddle (with megaphone), Gary Cox, and Clifford Trout. (Bill Henley.)

Lewiston High School students return from a DECA convention on March 14, 1960. From left to right are (first row) Doug Harris, Kate Worthington, and Carol Baenen; (second row) Jim Wagner, Linda King, and Monte Van Sise. They all were seniors graduating in the class of 1960. (Ron Karlberg.)

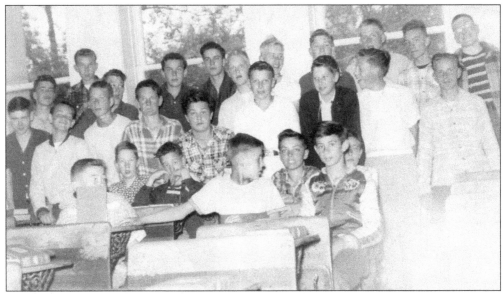

This is the class of 1957's eighth-grade boys' health class, lead by Harvie Walker, in about 1953. From left to right are (in desks) Ron Gustin, John Nail, B. White, John Mahoney, Jerry Kelp, D. Young, and Louis Kight; (standing, first row) Fred Walker, Jerry Gipson, Ray Sullivan, Bob Edmonson, R. Wright, John Hall, Paul Barnes, Mick Woodland, and Ken Reaves; (standing, second row) Clyde Northrup, Jerome Finnell, Waymon Gay, Bill Rasmussen, Mike McCann, Bill Henley, Gene Lawrence, Joe Dickeson, Duane Ailor, Larry Reed, and Carl Maxwell. (Bill Henley.)

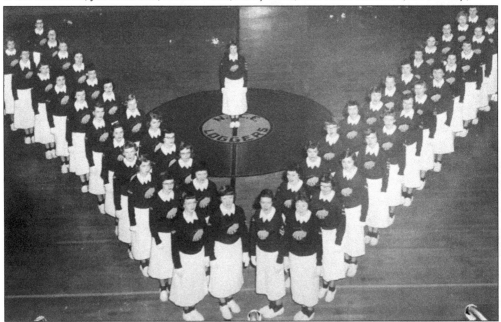

The Bengal Claws was a girl's precision marching team at Lewiston High School. They performed at basketball games, footballs games, and the annual Roundup parade. The outfits were dark purple wool sweaters with a big embroidered gold claw on the front and homemade white corduroy skirts, purple socks, and white shoes. Sometimes, they wore white gloves when they marched. (Lewiston High School Publications.)

Six

I WALK THE LINE

In 1904, Anne Bollinger's father, William Bollinger, built the Bollinger Hotel in Lewiston. Anne was an American opera soprano who studied with Lotte Lehmann and Rosie Miller. Her last visit to Lewiston was during January 1962, where she gave a full-length concert at Lewis-Clark State College. Recently, her two-piece flapper dress was donated to the Nez Perce County Historical Society Museum, along with her songbook. (Nez Perce County Historical Society Museum.)

In this iconic photograph from 1969, Ken Mansfield (in white), class of 1956, sits on a bench with Yoko Ono on the rooftop as the Beatles perform their last concert together. Mansfield was the US manager of Apple records and is a songwriter associated with many popular performers. He the author of five books, including *The Beatles, the Bible, and Bodega Bay: My Long and Winding Road*, and has a Grammy and a Dove Award. Now a minister, he is the brother of Dale Mansfield, class of 1960. (Ken Mansfield.)

Stan McMurray, class of 1960, was cofounder of Costco. After the Army, he worked at Potlatch but quit that and started a new concept called Warehouse Foods (which was Tidymans). McMurray had the concept for Costco, and in 1982, eight investors were brought together by an entrepreneur. McMurray hocked everything they had to get the first Costco going in Seattle. It opened in 1983, and "the rest is history." As a founding officer, McMurray was recognized nationally for his role at Costco, including a listing as an honoree in *The Who's Who of American Business Leaders* in 1991 and a listing in *Marquis Who's Who in the World* 1982–1983, 1985–1986, and 1987–1988. McMurray passed away Friday, September 30, 2016, at the age of 74. (Charlotte McMurray.)

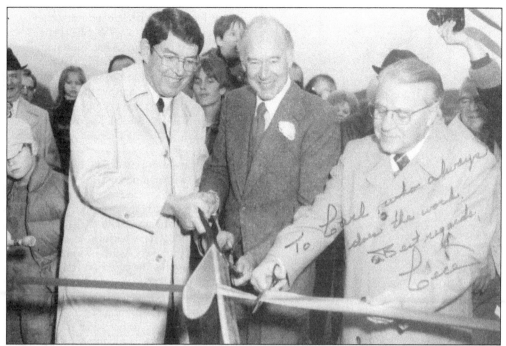

Carl Moore, chairman of the Idaho Transportation Board, cuts a ribbon dedicating the new Lewiston Hill. He is assisted by Idaho governor John Evans and US secretary of the interior Cecil Andrus in 1977. Moore served the public over 23 years, beginning in 1958 with two terms in both the Idaho House and Idaho Senate. He died in 1993. (Asotin County Historical Society.)

Local businessman Bill Skelton has the title of the longest-living juvenile diabetes patient in the United States, according to the Joslin Diabetes Center, an affiliate of Harvard Medical Center. His sister Mary is the second-longest-living patient. Bill has been battling diabetes for 66 years and taking injections for all that time. Shown from left to right are Bill Skelton, Mary (Skelton) Ausman, Mary's husband Pip Ausman, and Jim Bershaw. (Author's collection.)

This is Jennie Welch Gere, grandmother of Dave Welch, class of 1958. She spent many years raising the Gere children and later married Albert Gere, after the first Mrs. Gere died. Jennie had been future actor Richard Gere's nanny through his childhood and then became his stepmother. (Dana Rae McKay Williams.)

Agatha Evans was a niece of Chief Timothy's (who camped with Lewis and Clark) by marriage. She was part Nez Perce and received money from the Nez Perce Treaty. She moved up the river and bought the local ferry with the money. Eventually, the town Agatha was named after her. Agatha was Lewiston resident James V. "Jim" Roberts's great-grandmother. Jim remembers Nez Perce tribal members coming to his great-grandmother's house and paying homage to her when he was quite young. In a twist of fate, while in Lewiston, Agatha sold a home to Kermit Malcom, and later in life, Jim married the Malcoms' daughter Sandra. (Nez Perce County Historical Society and Museum.)

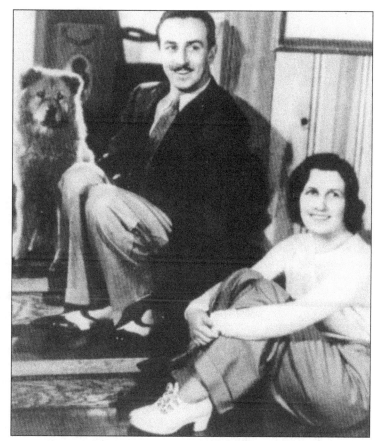

On July 13, 1925, Lillian M. Bounds, formerly of Lapwai, and Walt E. Disney, who produced *Walt Disney Comics*, were married at the home of the bride's brother Sidney C. Bounds on Third Street in Lewiston. The Reverend D.J.W. Somerville, director of the Lewiston Episcopal Church, performed the ceremony. Following that, the couple departed for Spokane and the coast. Lillian attended business college in Lewiston for one year. (Nez Perce County Historical Society and Museum.)

From 1952 to 1974, Lewiston, Idaho, had a minor-league baseball team. The organization was formed in 1952 by Lewiston businessmen. Reggie Jackson was the most famous Lewiston Bronc. Years later, Jackson told *Sports Illustrated* that he felt racism in Lewiston. Jackson claimed he was refused treatment during an overnight stay at the local hospital, but hospital records confirm he was treated by Dr. William Bond. (Nez Perce County Historical Society and Museum.)

Chickie Berman is shown with his 12-year-old niece Susan in the Lewiston Orchards. She came to live with him following the untimely death of her father, Davie, in 1957. Prior to moving to Lewiston, brothers Chickie and Davie were into the "rackets" in Minneapolis. Davie Berman had Meyer Lansky's backing. In 1947, Davie moved his family to Las Vegas and took over the Flamingo Hotel the day after Bugsy Siegel was shot. Susan attended private schools, commuting back and forth to visit her cousins Dave and Donna. Susan had gained her own fame as a journalist, author, and screenwriter, but was murdered in December 2000. Fifteen years later, Robert Durst was charged with her murder. (Rosalie Thomas Bruce.)

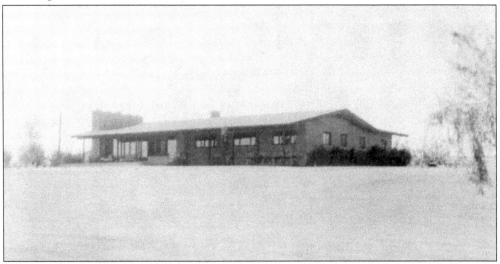

After years of living in a big city and suffering through harsh winters in Minnesota, the Bermans fell in love with the Lewiston valley. In the mid-1950s, they moved in with Chickie's wife's brother Tommy Thomas and his family while construction was under way on their home on Grelle Avenue. The house sat on 7.5 acres adjacent to the agricultural center, which sat between the house and the airport runway. (Rosalie Thomas Bruce.)

126

Hollywood came to Lewiston when Charles Bronson and his wife, Jill Ireland, came to star in *Breakheart Pass*, a movie filmed in Lewiston and the surrounding area. Bronson is shown taking a break during filming. He and Ireland stayed at attorney Wynn Blake's home while in Lewiston. Many locals have stories of how the stars would go out shopping and act just like everyone else. There was a premiere held at the Liberty Theater. (Nez Perce County Historical Society and Museum.)

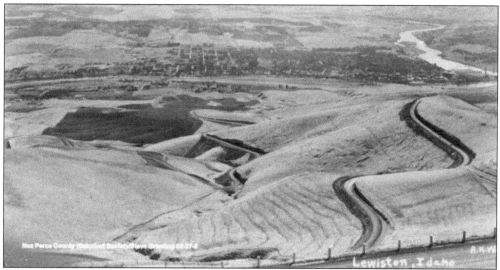

"Hot Rod Lincoln" was a song that was very popular around the valley when it first came out in 1955. It was written by Charlie Ryan, and many knew that the Cadillac sedan racing up the Lewiston Spiral Highway in the song was driven by a friend of Ryan's from Lewiston. Later, Ryan changed the setting of the race to the Grapevine Hill in California. (Nez Perce County Historical Society and Museum.)

Visit us at
arcadiapublishing.com

CPSIA information can be obtained
at www.ICGtesting.com
Printed in the USA
BVHW020918151222
654213BV00007B/1017